The Women of
Beaver Hall

The Women of
Beaver Hall
CANADIAN MODERNIST PAINTERS

Evelyn Walters

DUNDURN PRESS
TORONTO

Copy-editor: Jennifer Gallant
Design: Jennifer Scott
Printer: Friesens

Library and Archives Canada Cataloguing in Publication

Walters, Evelyn, 1939-
 The women of Beaver Hall : Canadian modernist painters / Evelyn Walters.

Includes bibliographical references.
ISBN-10: 1-55002-588-0
ISBN-13: 978-1-55002-588-0

 1. Women painters--Canada. 2. Beaver Hall Group (Group of artists). I. Title.

ND248.W34 2005 759.11'082 C2005-904875-1

1 2 3 4 5 09 08 07 06 05

Conseil des Arts du Canada Canada Council for the Arts Canadä ONTARIO ARTS COUNCIL / CONSEIL DES ARTS DE L'ONTARIO

We acknowledge the support of the **Canada Council for the Arts** and the **Ontario Arts Council** for our publishing program. We also acknowledge the financial support of the **Government of Canada** through the **Book Publishing Industry Development Program** and **The Association for the Export of Canadian Books**, and the **Government of Ontario** through the **Ontario Book Publishers Tax Credit program**, and the **Ontario Media Development Corporation**.

Care has been taken to trace the ownership of copyright material used in this book. The author and the publisher welcome any information enabling them to rectify any references or credits in subsequent editions.

J. Kirk Howard, President

Printed and bound in Canada.
www.dundurn.com

Dundurn Press
3 Church Street, Suite 500
Toronto, Ontario, Canada
M5E 1M2

Gazelle Book Services Limited
White Cross Mills
Hightown, Lancaster, England
LA1 4X5

Dundurn Press
2250 Military Road
Tonawanda, NY
U.S.A. 14150

This little book is dedicated — to my sisters in toil, the tired and over-tasked women, who are wearing their lives away in work which has little hope and less profit...

— Eliza M. Jones, grandmother of Prudence Heward, preface to Dairying for Profit; or, The Poor Man's Cow, *1892.*

TABLE OF CONTENTS

ACKNOWLEDGEMENTS

Many people made this project possible and must be thanked.

The gathering of over seventy illustrations gleaned from private collections and museums across Canada required the cooperation of many dedicated people: Christine Braun of the Art Gallery of Hamilton; Andrea Dixon of the National Gallery of Canada, Ottawa; Nathalie Garneau of the Leonard & Bina Ellen Gallery, Montreal; Cassandra Getty of the Art Gallery of Windsor; Annabel Hanson of the Agnes Etherington Art Centre, Kingston; Quyen Hoang of the Glenbow Museum, Calgary; Véronique Malouin of the Musée d'art contemporain de Montreal; Heather McNabb of the McCord Museum, Montreal; Brian Perry of the Beaverbrook Art Gallery, Fredericton; Phyllis Smith of the Musée national des beaux-arts du Québec, Quebec City; and Marie-Claude Saia of the Montreal Museum of Fine Arts.

Kirk Howard, publisher of the Dundurn Group, for his commitment to the project; Tony Hawke, the editor, for his enthusiasm; Jennifer Scott for

coping so well with the large number of images; Jennifer Gallant, the copy-editor; and all who worked behind the scenes.

Those who generously permitted the use of images that were integral to the book: J.B. Claxton, QC; Dr. and Mrs. Byrne Harper; Susan Kilburn; Eric Klinkhoff; Barbara Marcolin; Dean May; Francis Newton; and A.K. Prakash.

Those who advised and assisted with research: Faith Berghuis; Kim Brittain; Johanna Chipman; Heward Grafftey, PC; Chil Heward; Nathalie Hodgson; Francis Newton; Anne McDougall; Leah Sherman; and Matthew Walters.

Ultimate thanks go to those no longer with us — the women of Beaver Hall who left behind a legacy of the finest in Canadian art.

INTRODUCTION

Named after their studio location at 305 Beaver Hall Hill in Montreal, the official Beaver Hall Group was organized in 1920 with A.Y. Jackson as president. Largely overlooked at the time, it has since emerged as the Quebec counterpart to Ontario's Group of Seven established in the same year. Unlike the male-dominated Group of Seven, the Beaver Hall Group was open to both men and women. At its first annual exhibition on January 17, 1921, A.Y. Jackson said its purpose was "to give the artist the assurance that he can paint what he feels, with utter disregard for what has hitherto been considered requisite to the acceptance of the work at the recognized art exhibitions in Canadian centres. Schools and 'isms' do not trouble us; individual expression is our chief concern."[1]

The show included the works of eleven men and eight women, but it was the women painters who evoked the most enthusiasm in the *Gazette*'s review.[2] In all, they held only four exhibitions.

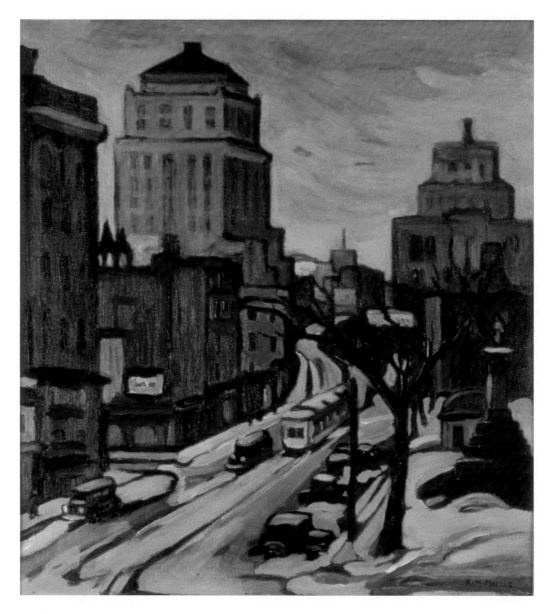

Kathleen Moir Morris
Beaver Hall Hill, 1936
Oil on canvas
76.00 x 71.50 cm
Glenbow Museum Collection
Gift of the Estate of Norman E. Swyers

Although there is debate as to the Group's official duration, it seems to have been in existence from 1920 to 1922. Following its demise due to financial problems, a network of the members and their associates continued to be identified by the name. In staying together they found it easier to obtain exhibition space and to attract attention. Paul Duval noted that the Beaver Hall Group "provided a strong impetus to the careers of many of the finest women painters Canada has so far produced."[3]

The ten most prominent women members were Nora Collyer (1898–1979), Emily Coonan (1885–1971), Prudence Heward (1896–1947), Mabel Lockerby (1882–1976), Henrietta Mabel May (1877–1971), Kathleen Morris (1893–1986), Lilias Torrance Newton (1896–1980), Sarah Robertson (1891–1948), Anne Savage (1896–1971), and Ethel Seath (1879–1963).

Most, with the exception of Emily Coonan, remained lifelong friends. They painted, exhibited, and travelled together at a time when it was not socially acceptable for women to travel alone. There seems to have been some rivalry between Heward and Savage, but as a group they exchanged ideas and critiqued each other's work. Savage recalled, "There was a remarkable spirit. We telephoned one another, 'Have you got anything? What are you doing? Can I come up and see it? Could you come down?' We had a swell time actually."[4]

All but Coonan came from the English establishment in Montreal, yet not all enjoyed financial security. Coonan, Robertson, and Savage lived in households of women and helped to support the family. May, Torrance Newton, Savage, and Seath taught art to supplement a meagre income from painting. However, in keeping with social obligations, they always found time to care for

the ill and to volunteer for charitable causes. In a society where marriage and a career for a woman were considered incompatible, only Torrance Newton married, albeit briefly, and the others, whether by choice or not, remained single.

All of the Beaver Hall women attended the Art Association of Montreal, the forerunner of today's Montreal Museum of Fine Arts, which played an important role in art education during the first part of the century. Guest lectures and exhibitions were held regularly, and the reading room was well stocked with periodicals, catalogues, and books. The students followed an exacting program of classical study based on the standard drawing and painting classes.

Among their noteworthy teachers were the artists Maurice Cullen, Randolph Hewton, and the demanding William Brymner, who served as the director for thirty-five years and left a lasting impression on his students. Having trained in Paris at the Académie Julian, Brymner organized the school on the Parisian model,

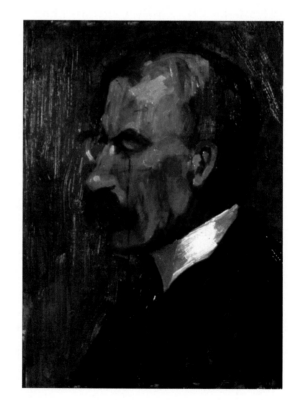

Anne Savage
Portrait of William Brymner, 1919
Oil on wood
22.86 x 17.78 cm
Art Gallery of Hamilton
Gift of the artist, 1959

passed on his enthusiasm for new developments, and never failed to emphasize the importance of self-expression. Social convention dictated that women be self-effacing and their painting merely a pastime, yet he encouraged them by arranging scholarships for the talented.

Despite their Victorian curriculum, the young women were very aware of the changes occurring in Canadian art. Painting in Canada had begun with the naïve drawings of the explorers, followed by portraits, predominantly for the Church, and then by landscape paintings in the European manner. At the turn of the twentieth century artists such as Lawren Harris, John Lyman, David Milne, and James Wilson Morrice, after studies in Paris, were adopting the techniques of the Post-Impressionists.

The European movement, which attracted hundreds of foreign artists to France, had spanned a period from about 1886 to the beginning of Cubism in 1906, but North America was slow to adopt the change. In reviewing the 1913 Art Association of Montreal's spring exhibition, Morgan Powell of the *Montreal Daily Star* decried the artists' "imitations" of Post-Impressionism: "Post-impressionism is a fad, an inartistic fetish for the amusement of bad draughtsmen, incompetent colourists, and others who find themselves unqualified to paint pictures"[5]; five years later he again dismissed their style as "rough splashy meaningless blatant plastering and massing of unpleasant colours in weird landscapes ... the same blustering spirit of Post-Impressionism, all conveying the same impression that the artist didn't know how to do it, and wasted considerable good pigment in a disastrous attempt."[6]

However, in 1913 the Armory Show in New York, with its Impressionist, Post-Impressionist, Cubist, and Futurist paintings, challenged the prevailing academic and public attitude towards Modernism and eventually altered the course of art history in America.

The First World War resulted in a strong sense of nationalism that prompted artists to search for an identifiable Canadian art. The Group of Seven believed that it could be found in the large canvases of rugged Northern Ontario landscapes. After studies in Paris, members of both the Group of Seven and the Beaver Hall Group were enthusiastically experimenting with colour, light, and technique. However, in the 1920s Montrealers were still confused by the direction art had taken. Morgan Powell continued to berate the women for paintings "marred by crudity of colouring, harsh tones, and neglect of drawing."[7] Albert Laberge of *La Presse* was more encouraging: he praised the Beaver Hall artists for their originality and compared them to the Paris Indépendents.[8]

With the exception of Savage, the Beaver Hall women did not concern themselves much with nationalism. They were more interested in technique and with shifting the emphasis from dominant landscape imagery to more personal aspects of expression. Many embraced the Quebec francophone tradition that landscapes include signs of habitation: the picture could be devoid of man himself, but not of his tools, buildings, or other imprints of civilization.[9] For the most part the Beaver Hall paintings are small in scale, depict tranquil country scenes, and combine both Modernist and traditional forms of expression.

A.Y. Jackson provided an important link between the Group of Seven and the Beaver Hall Group. As a member of both, he encouraged the women to free themselves of their old-fashioned academic training and to disregard accepted female stereotypes. Eric Brown, director of the National Gallery of Canada from 1912 to 1939, was another mentor. Despite the controversy over his support of Canadian Modernism, he did not hesitate to purchase their works, mount their exhibitions, and arrange for international exposure. He was instrumental in having the women participate in the 1924 Wembley show in England, where, unlike at home, they enjoyed an enthusiastic reception. It is because of Brown's foresight that the National Gallery today has the most extensive collection of Beaver Hall paintings.

At a time when there were few private galleries and the public preferred the Old Dutch masters, the artists had to rely on societies and associations for recognition and marketing. During the 1920s and 1930s the Group of Seven dominated the Canadian art scene, and although they sometimes invited members of the Beaver Hall Group to exhibit with them, the women were usually ignored.

Unless, that is, they caused a stir. Such was the case when Heward and Torrance Newton challenged Canadian prudery by exhibiting nude portraits, which was doubly offensive because the painters were women. Having in mind the 1934 incident when the Art Gallery of Toronto refused to hang Torrance Newton's *Nude in a Studio*, Donald W. Buchanan in the *Canadian Forum* decried the "perverse logic that pervades the miasma of the censoring minds":

Simply paint a model naked in a studio, let the figure be not veiled in a wistful aurora, or let her be not poised alone in a wilderness of rocks and distant forests, but be standing solid and fleshly, like a Renoir maid-servant, and then taboo — you are out and in the basement.[10]

Except for Coonan, the Beaver Hall Group continued to forge ahead. They exhibited together and played an active role in the art community. Heward, May, Torrance Newton, Robertson, and Savage were on the executive committee of Atelier, a school of modern art in Montreal. Founded in 1931 for more progressive artists, it survived only two years, but it did provide working space and opportunities. In 1933 the Canadian Group of Painters, made up of twenty-eight members from across the country, was created in an effort to go beyond the Group of Seven and the Canadian preoccupation with landscape. Again Heward, May, Torrance Newton, Robertson, and Savage were among the original members, and their participation raised the prestige of women artists in general. One of the longest lasting of the art community's organizations, it eventually disbanded in 1967. In an attempt to bring together French and English artists, the Contemporary Art Society was founded in 1939, but continued only until 1948. It was anti-academic, emphasizing imagination, intuition, and spontaneity. Heward, Lockerby, Savage, and Seath joined, but they had less influence there than in the other groups.

Along with their professional struggles, the Beaver Hall women endured the devastating effects of two world wars. They lost friends and family members but continued to do their part for the war effort. Some volunteered for the Red Cross; others opened their doors to evacuees, donated works for refugee benefits, or participated in the war art projects. During the First World War Mabel May, commissioned by the government, painted workers in munitions factories; during the Second World War Heward designed war posters and Torrance Newton painted military portraits, while Seath, Morris, and Lockerby produced war paintings in an attempt to illustrate the experience for those at home.

After the Second World War the Beaver Hall Group found themselves in the vanguard of a dramatically changing society. No longer was the traditional role of stay-at-home wife and mother the only acceptable choice for women: they were able to further their education and to pursue careers. Female artists could now sell their paintings rather than give them away, and it was easier to be part of the male-only art associations. The robust postwar economy and the growing numbers of galleries and art education departments offered them many more opportunities than they had had previously.

Throughout the ensuing years the Beaver Hall women continued to show their paintings, both at home and internationally, but gained little recognition. The National Gallery held memorial exhibitions for Prudence Heward in 1948 and for Sarah Robertson in 1951, but not until the feminist movement of the 1960s did interest turn towards women painters. The National Gallery organized *The Beaver Hall Hill Group* travelling exhibition

in 1966, but it was another eleven years before Anne McDougall's book *Anne Savage: The Story of a Canadian Painter* appeared.

Gradually significant milestones were being reached. Public institutions such as the National Gallery, the Agnes Etherington Art Centre, the London Regional Art Gallery, and the Sir George Williams Art Galleries continued to collect and mount the Group's work in an attempt to keep them before the public. The highly respected Walter Klinkhoff Gallery in Montreal held a Nora Collyer show in 1964, but it was another twenty-five years before it began to hold retrospective exhibitions for the Group on a regular basis. By 1995 the National Film Board had produced the documentary *By Woman's Hand*, which explored the life and times of three of the artists — Heward, Robertson, and Savage. Drawing upon its own collection in 1997, the Montreal Museum of Fine Arts organized *Montreal Women Painters on the Threshold of Modernity*, and in 1999 Barbara Meadowcroft wrote *Painting Friends: The Beaver Hall Women Painters*.

Today, Beaver Hall paintings are increasingly sought out by collectors, galleries, and large auction houses, where they now rival the Group of Seven in popularity. The women of Beaver Hall are at last receiving the recognition they deserve.

Nora Collyer (1898–1979)

In a letter to A.Y. Jackson after one of her frequent visits to the Collyer's cottage, Anne Savage wrote, "Nora is one of the loveliest people imaginable, so unpretentious, so apparently listless and apathetic and so full of fun and constant chatter, thoughtful and planning for everyone."[11]

Nora Frances Elizabeth Collyer grew up on Tupper Street and later Dorchester Boulevard in Montreal. Her parents were Gertrude Ellen Palmer and Alfred Collyer, a graduate of McGill University and owner of a firm that manufactured electrical appliances. While attending Trafalgar, a private girls' school, she took classes at the Art Association of Montreal, and after graduation she continued her studies there with Alberta Cleland, Maurice Cullen, and William Brymner. She joined the Beaver Hall Group in 1920, and in 1925 she returned to Trafalgar to teach drawing for a yearly salary of $800, but left when her mother died in 1930. As the only daughter, she had to assume the responsibility of managing the household for her father and brother.

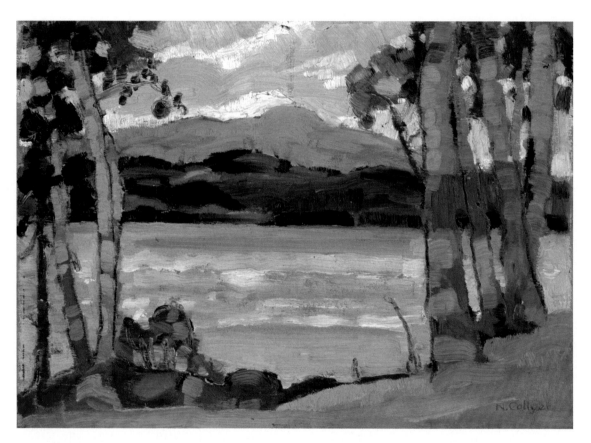

Nora Collyer
[Landscape], n.d.
Oil, pencil (?) on panel
23.4 x 32.8 cm
Gift of Anne Savage's heirs: Anne McDougall, Galt MacDermott,
Mary Drummond, Helen Leslie, John Claxton
Coll: The Montreal Museum of Fine Arts
Photo: Christine Guest, MMFA
1997.142

Like her parents, who were members of the English Protestant elite, Collyer had a strong sense of community service. A gifted educator, she taught Saturday mornings at the Art Association of Montreal, held classes in her home, and volunteered at the University Settlement, the Griffintown Club, and the Children's Memorial Hospital. Travels to Europe, Bermuda, the Lower St. Lawrence, and Nova Scotia broadened her education and inspired her painting.

Hillcrest, the family cottage in Foster, was one of the popular weekend gathering places for her Beaver Hall friends. Of a shy and reserved personality, Collyer complemented her outgoing long-time companion, Margaret Reid, an executive secretary at Dominion Oilcloth. They lived together at 3400 Ridgewood Avenue and later on Elm Avenue in Westmount. From 1950 to 1967 they spent their summers at Strawberry Hill, the cottage they built overlooking Lake Memphremagog near Foster.

The sketching trips Collyer took as a student with Maurice Cullen left his mark on her work. Her technique is never harsh and is remarkable for its shapes, rich colour, and soft rhythms. Rarely figurative, her favourite subjects are flowers, woods, riverscapes, old houses, churches, and villages. In 1922 Albert Laberge, art critic of *La Presse*, proclaimed that the boldest, most brilliant works at the Art Association's spring exhibition were by women, referring to Lockerby, May, and Collyer.[12] Morgan-Powell of the *Montreal Star*, known for his anti-Modernist diatribes, managed a compliment: "Miss Nora Collyer in *The Yellow Balloon* and *Daisy* shows feeling for colour contrasts."[13]

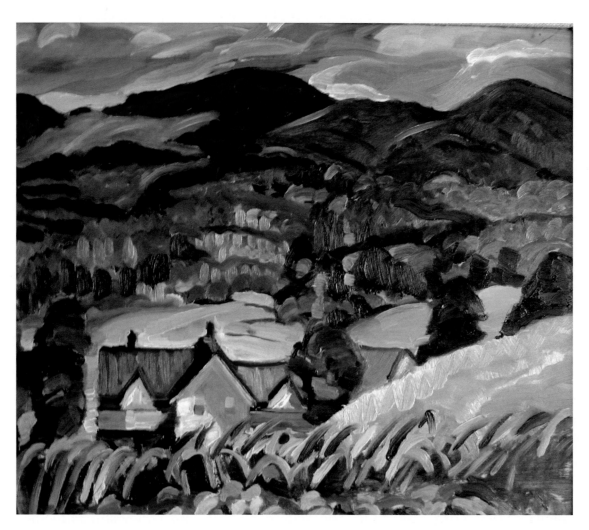

Nora Collyer
House, Bolton Pass Road, 1939
Oil on board
22.8 x 35.6 cm
Private Collection, Toronto

Her Eastern Township landscapes, such as *House, Bolton Pass Road*, reveal a partiality for the area near her summer home. In 1964 Robert Ayre of the *Montreal Star* wrote, "She loves ripeness, the snugness of villages in the hills, and celebrates them in full-bodied colour and easy, comfortable rhythms."[14] Her Montreal cityscapes often include landmarks such as Mount Royal Park.

In later years Collyer devoted her time to nursing Margaret Reid, who had developed Alzheimer's disease. On June 11, 1979, twelve days after Reid's death, Collyer died at the age of eighty-one.

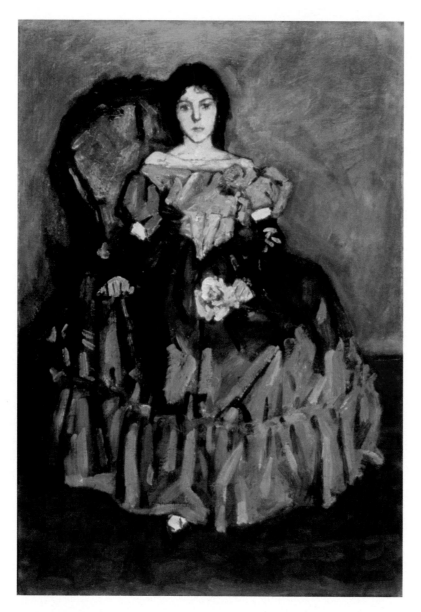

Emily Coonan
Girl with a Rose, 1913
Oil on canvas
76.6 x 53.5 cm
National Gallery of Canada
Purchased 1997

CHAPTER TWO
Emily Coonan (1885–1971)

"A very odd, shy, strange person … a real loner," replied Torrance Newton when asked about fellow artist Emily Coonan.[15]

Born to a respectable but poor Irish Catholic family in Point St. Charles, Emily Geraldine Coonan was the only member of the Beaver Hall Group that did not belong to the Montreal establishment. Her parents were William Coonan, who worked as a machinist for the Grand Trunk Railway, and Mary Anne Fullerton. Determined to have their children well educated, they made sure money was available for music and art lessons. Mr. Coonan could often be seen walking the considerable distance to the library and returning with armloads of books for his family.

Emily's early education took place at St. Ann's Academy for Girls, a neighbourhood Catholic school. In the late 1890s she began her art studies at the Conseil des Arts et Manufactures, which was funded by the Quebec government to improve the province's industry. Among her teachers were

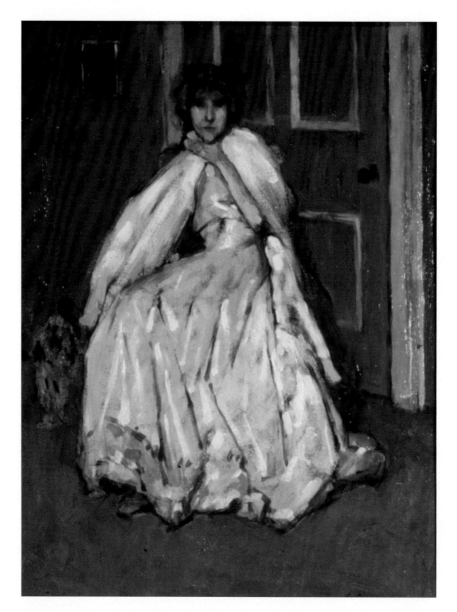

Emily Coonan
Girl in Green, 1913
Oil on canvas
66.4 x 49.0 cm
Art Gallery of Hamilton
Gift of A.Y. Jackson, C.M.G., R.C.A., 1956

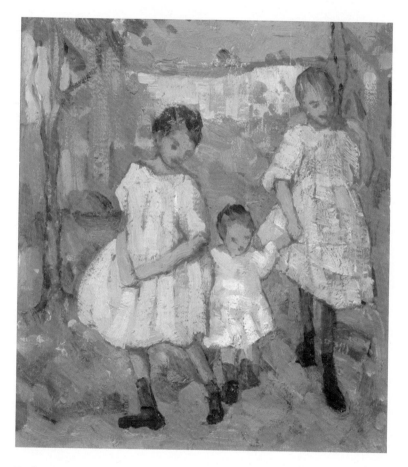

Emily Coonan
En promenade, c. 1915
Oil on board
30.5 x 27 cm
Private Collection, Ontario

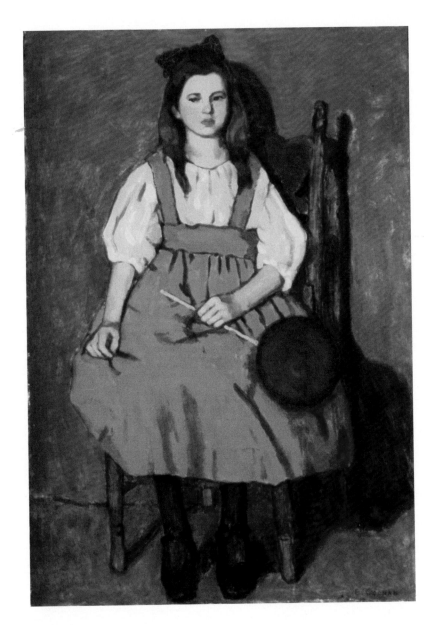

Emily Coonan
The Green Balloon, 1919
Oil on canvas
88.9 x 63.9 cm
National Gallery of Canada
Purchased 1920

Joseph Franchère, Charles Gill, Joseph St. Charles, and the innovative Edmond Dyonnet, an influential painter from France. She went on to attend the Art Association of Montreal from about 1905 until 1912 in spite of the financial burden and her social background. An outstanding student, she soon became William Brymner's star pupil. In 1910 the *Herald*'s critic wrote, "The oil *Evelina, 1830* an arrangement in lavender, violet and white indicates the work of a born colorist of more than average talent."[16] Coonan sold the painting for the then remarkable price of fifty dollars. Encouraged by Brymner, Coonan and fellow student Henrietta Mabel May travelled to France, Belgium, and Holland in 1912, where, according to Coonan, they "painted all the time."[17]

Coonan's earliest works— icons and portraits for the neighbourhood church — were inspired by her surroundings. Studies with Brymner and his enthusiasm for the French Impressionists as well as her own admiration for the works of James Wilson Morrice began to influence her painting. During this time, portraits, interiors, and groups of children were her favourite subjects. By 1913 the *Daily Herald* in its review of the Art Association's spring exhibition was referring to her as the Point St. Charles prodigy and declared, "Miss Emily Coonan … has a group in her highly characteristic style and a portrait [*Girl in Green*] which shows a distinct advance in the sense of form."[18] The *Saturday Mirror* proclaimed, "The portrait of a girl in a green dress is splendidly painted and manifests all this young artist's skilful management of delicate tones."[19] The following year she became the first recipient of the National Gallery Travel

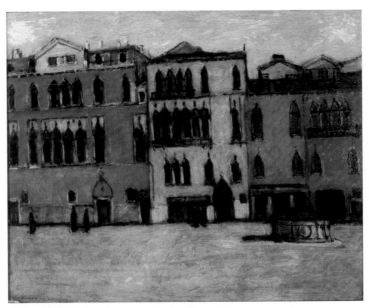

Emily Coonan
Untitled, (Santa Maria Formosa), 1920-1921
Oil on wood panel
30.5 x 40.6 cm
Collection of the Leonard & Bina Ellen Art Gallery, Concordia University
Max and Iris Stern Acquisition Fund
988.06

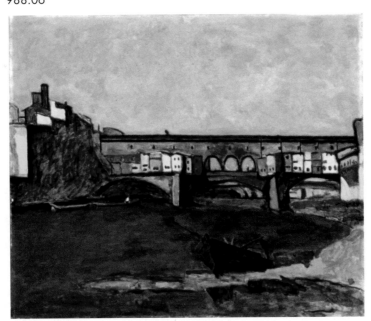

Emily Coonan
Ponte Vecchio, Florence, c. 1921
Oil on canvas
76.6 x 92 cm
National Gallery of Canada
Purchased 1922

Grant to study in Europe, but because of the war her trip was postponed until 1921. Her paintings indicate that she visited Florence, Venice, Paris, and London.

By the 1920s her figurative works, such as *Girl in Dotted Dress*, chosen for the British Empire Exhibit in Wembley, began to show Modernist influences: the background devoid of detail, the face simplified, and accessories eliminated. She placed more emphasis on the expressive possibilities of the medium than on capturing a true likeness of the model. Despite Morgan-Powell's criticism of the "glaring colour and rough drawing," the work was well received in England and by her peers.[20] Although Coonan was one of the first women invited to exhibit with the Group of Seven, she did not adopt their nationalist agenda. Her later paintings are mostly Impressionistic landscapes in the francophone tradition like those of Morrice.

Coonan joined the Beaver Hall Group but did not become lifelong friends with any of the members. Unlike the others, she exhibited for only a short period of time, mostly between 1908 and 1930. Why she stopped is not clear. There is some speculation that she had a disagreement with the Art Association of Montreal, or that since she already had three paintings in the National Gallery she no longer wanted to expose herself to unwarranted criticism. Consequently, during the 1930s and 1940s, when the Beaver Hall women were gaining recognition, Coonan was ignored. For the next thirty years, she chose to work on her own, taking regular sketching excursions to the Lower St. Lawrence with her family.

Emily Coonan
Italian Girl, c. 1921
Oil on canvas
107.0 x 85.5 cm
Collection of the Leonard & Bina Ellen Art Gallery, Concordia University
Max and Iris Stern Acquisition Fund
994.06

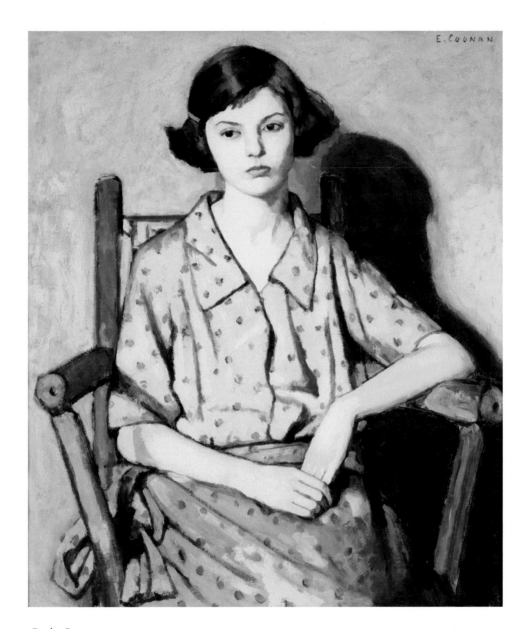

Emily Coonan
Girl in Dotted Dress, c. 1923
Oil on canvas
76.0 x 66.4 cm
Art Gallery of Hamilton
Gift of The Hamilton Spectator, 1968

A devout Catholic with strong opinions, Coonan preferred her privacy. Except for the last three years, when she lived with her niece, most of her eighty-six years were spent in the family home on Farm Street where she was born. She died in Montreal on June 23, 1971.

Prudence Heward (1896–1947)

At a time when painting was little more than a fashionable activity for women, it became a passion for (Efa) Prudence Heward.

Her parents were Arthur R.G. Heward, a CPR official, and (Sarah) Efa Jones, respected members of the Montreal establishment. The Jones family were originally United Empire Loyalists who had settled in the Brockville area of Ontario. Heward's grandfather, Chilion Jones, was one of the architects of the original parliament buildings in Ottawa. Her grandmother, Eliza Jones, ran a dairy farm with such great success that in 1892 she was encouraged to write a book on the subject, *Dairying for Profit; or, The Poor Man's Cow*.[21]

When Prudence was sixteen her father died, leaving her mother to support eight children. Despite the many vicissitudes of the ensuing years, Efa Heward maintained a high-spirited and secure home life for her children. In 1939, after years of financial constraint, the family's circumstances improved

Prudence Heward, 1931
Photo by Melvin Ormond Hammond
21.4 x 16 cm
NGC Library
62789

considerably with an inheritance from Efa Heward's brother, Frank Jones, the renowned president of Canada Cement.

Because of her health, Prudence Heward's early education took place at home. She began taking drawing lessons at the age of twelve, and eventually in 1918 she enrolled in the rigorous program at the Art Association of Montreal. Her teachers were William Brymner, Randolph Hewton, and Maurice Cullen, popular for his outdoor sketching classes at Phillipsburg and Carillon.

Modern trends in European art were to have a profound effect on Heward's work. From 1925 to 1926 she studied in Paris with the illustrator Bernard Naudin and with Charles Guerin at the Académie Colarossi, a school established in the nineteenth century as an alternative to the ultra-conservative École des Beaux Arts. Always mindful of social proprieties, Heward stayed at the fashionable Hôtel Lutetia, removed from the vitality of the bohemian artists and their ateliers.

Prudence Heward
Girl on a Hill, 1928
Oil on canvas
101.8 x 94.6 cm
National Gallery of Canada
Purchased 1929

Prudence Heward
At the Theatre, 1928
Oil on canvas
101.6 x 101.6 cm
Purchase, Horsley and Annie Townsend Bequest
Coll: The Montreal Museum of Fine Arts
Photo: Brian Merrett, MMFA
1964.1497

Prudence Heward
Rollande, 1929
Oil on canvas
139.9 x 101.7 cm
National Gallery of Canada
Purchased 1930

Prudence Heward
Sisters of Rural Quebec, 1930
Oil on canvas
157.4 x 106.6 cm
Collection of the Art Gallery of Windsor
Gift of the Women's Committee, 1962

She returned to Europe again in 1929 to attend the Scandinavian Academy in Paris and to sketch in Cagnes-sur-mer, Venice, and Florence.

Most of Heward's painting was done in a top-floor studio at her home on Peel Street amidst the stifling odours of paint and cigarette smoke, an environment that must surely have aggravated her asthma. Known for her fashionable taste, she decorated her bedroom in the latest Art Deco style — a silver bed, black lacquer chest of drawers, glass sconces, mirrored screens painted with her own designs, and a colour scheme of grey, chartreuse, and red accents. Her nieces and nephews recall her elegant dress and her convertibles — the first yellow with a rumble seat and later a grey-blue Hudson.

Heward's landscapes were inspired by visits to St. Sauveur, her sister's farm in Knowlton, and Fernbank, the summer place near Brockville, where she found an abundance of rural houses, barns, churches, fields, and local country views. On occasion her subjects would be expanded by a holiday, perhaps to Bermuda where the industrialist family of her artist friend Isabel McLaughlin had a villa. In 1935, Robert Ayre, critic of the *Montreal Gazette*, impressed by her landscape painting, wrote:

> The great solid body of the earth goes rolling through Prudence Heward's *Shawbridge* and her *Piedmont* picture in a rich pattern of hillfolds, colored trees and water. Never content with mere surface impressions Miss Heward is a painter of

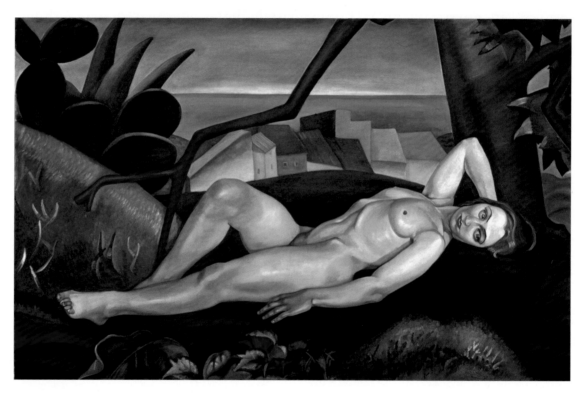

Prudence Heward
Girl Under a Tree, 1931
Oil on canvas
122.5 x 193.7 cm
Art Gallery of Hamilton
Gift of the artist's family, 1961

Prudence Heward
Mulleins and Rocks, c. 1932–1939
Oil on plywood
30.3 x 35.6 cm
National Gallery of Canada
Gift of the Heward family, Montreal, 1948

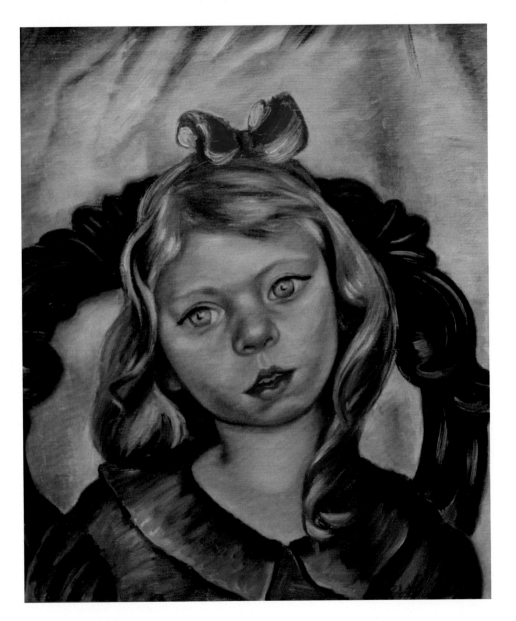

Prudence Heward
Study for *Farmhouse Window*, c. 1938
Oil on canvas
51.4 x 44.5 cm
Coll: Laura and Byrne Harper

profound integrity, a painter who both stimulates and satisfies.[22]

Heward was at the height of her career during the late 1920s and the 1930s when Modernist influences began to appear in her work. Exhibiting with the Group of Seven in 1928 brought her great critical acclaim, as did winning the National Gallery's Willingdon Prize in 1929 for *Girl on the Hill*, a portrayal of the Montreal dancer Louise McLea. *At the Theatre*, with Sarah Robertson's sisters as models, and *Rollande* caught the attention of the *Toronto Telegram*'s critic, who in 1930 observed, "her two remarkable paintings ... resemble no one else in their individual form of expression."[23] That same year, the National Gallery of Canada purchased *Rollande* for $600, an extraordinary price at the time. During the 1930s and 1940s, when the conservative Montreal Museum of Fine Arts would not show her nudes, Heward boldly exhibited *Girl Under a Tree* with the Group of Seven at the Art Gallery of Toronto.[24]

Heward is largely recognized for her figurative painting. The subjects are predominantly female: her nieces, friends, or the black models she hired with the help of the porters she met on the train when travelling to Fernbank. Her "figures" — the term she preferred over "portraits" — are studies of strong, serious, often sad or defiant women of the 1930s set in a metaphorical landscape. She uses bold colours, crisp angular lines, strong patterns, full forms, and expressive brushstrokes to emphasize the socio-economic and psychological despair in the faces of her subjects. Fellow artist Edwin Holgate in his tribute to her in 1947 wrote:

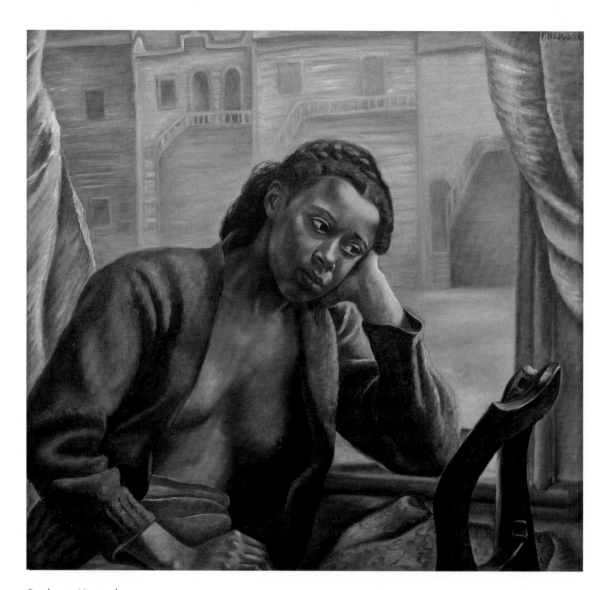

Prudence Heward
Girl in the Window, 1941
Oil on canvas
86.4 x 91.5 cm
Art Gallery of Windsor
Given in memory of the artist and her sister by the estate of Gladys S. Nares, 1981
1981.006

> Strongly individual, carefully organized, her work
> was drawn with great fullness of form and painted
> with a richness and care which alone could bring
> out the contemplative aspect.... In still life and land-
> scape her colour was almost tropical in richness.[25]

Heward was keenly interested in redefining the role of women painters and committed to new developments. She was an enthusiastic member of the Beaver Hall Group, served on the executive committee of the avant-garde Atelier, was vice-president of the Canadian Group of Painters for five years, and was a founder of the Contemporary Art Society. To encourage the artistic endeavours of her friends and acquaintances, she hosted meetings at her city home or invited them to "painting picnics" at Fernbank.

A.Y. Jackson, her mentor and a frequent guest at Fernbank, often praised her artistic merits. Heward Grafftey recalled Jackson's reaction when he asked if his aunt Prue was one of Canada's best woman painters:

> He became slightly irritated and replied, "Heward,
> forget the woman part of your question. In my
> opinion, she was the very best painter we ever had
> in Canada and she never got the recognition she
> richly deserved in her lifetime. I wanted her to join
> the Group of Seven, but like the Twelve Apostles,
> no women were included."[26]

Prudence Heward
Pensive Girl, 1944
Oil on canvas
51 x 43.5 cm
Musée d'art contemporain de Montréal
Gift of the Max and Iris Stern Foundation
Photo: Denis Farley
D 88 121 P1

Heward's life was a delicate balance between illness, family tragedies, the expectations of her mother, and an ardent desire to pursue a career. A strong sense of social responsibility led her to spend two years volunteering with the Red Cross in London, England, during the First World War and to participate in the war effort during the Second World War.

As her illness became increasingly debilitating, she wrote to A.Y. Jackson that she missed her painting terribly. She died at the age of fifty-one at the Hospital of the Good Samaritan in Los Angeles, where she had hoped to find treatment for her asthma.[27]

Despite her short life, Heward became the most recognized of the Beaver Hall Group. A memorial exhibition was mounted in March of 1948 by the National Gallery of Canada. Reviewing the show, Paul Duval wrote in *Saturday Night*:

> Her painted world is one of sad reflections. Her subjects look out of their frames wondering and a little afraid. They strike one strongly as people living in a world which they cannot quite comprehend. ... [Heward was] one of the most sensitive painters this country has known.[28]

Prudence Heward
At the Café, n.d.
Oil on canvas
68.5 x 58.4 cm
Gift of the artist's family
Coll: The Montreal Museum of Fine Arts
Photo: Brian Merrett, MMFA
1950.1036
(portrait of Mabel Lockerby)

Mabel Lockerby (1882–1976)

As one of the oldest members of the Beaver Hall group, Mabel Irene Lockerby chose at times to give 1887 as her year of birth. From a woman who was seen to be unconventional, unsentimental, and opinionated,[29] cutting five years from her age is perhaps not surprising.

She spent most of her time between the family home at 408 Mackay Street in Montreal's elite Square Mile and a country house in Hudson, Quebec. Her parents were Alexander Lockerby, who ran a wholesale grocery business, and Barbara Cox. After her father's sudden death in 1915, Mabel, considered the most capable of the daughters left at home, took charge of the household. Although financially secure at the time, the family had to live on a significantly reduced income after the stock market crash in 1929, and by the late 1950s the sisters were forced to sell the Mackay Street property and move to 2036 Vendome Avenue.

Mabel Lockerby
March, n.d.
Oil on canvas
55.5 x 70.5 cm
National Gallery of Canada
Purchased 1926

Mabel Lockerby
Early Winter, c. 1927
Oil on canvas
65.9 x 76.6 cm
National Gallery of Canada
Purchased 1928

Mabel Lockerby
After a Snowstorm, n.d.
Oil on wood panel
30.5 x 22.5 cm
Mr. and Mrs. R.W. Heward Bequest
Coll: The Montreal Museum of Fine Arts
Photo: Christine Guest, MMFA
1975.33

Lockerby attended the Montreal High School for Girls, and much later, when she was in her mid-thirties, the Art Association of Montreal. She was a student of William Brymner and Maurice Cullen for about nine years, but unlike most of her friends she did not go on to study in Europe. Having joined the Beaver Hall Group in 1920, she remained part of the network long after its demise. She went on sketching excursions with her close friends Heward, Morris, and Robertson, and like them she exhibited regularly with both the Canadian Group of Painters and the Contemporary Arts Society.

An Impressionist technique together with a strong sense of composition and colour characterizes Lockerby's work. Her favourite subjects, sometimes presented in a naïve manner, were children, city streets, landscapes, and often her own pets. In 1922 Albert Laberge, art critic for *La Presse*, singled out Collyer, Lockerby, and May when proclaiming that in the Art Association of Montreal exhibition the boldest and most brilliant works are by women.[30]

During the late 1920s the National Gallery acquired Lockerby's *March, Early Winter* and the painting that received honourable mention in the Willingdon Arts Competition, *Marie and Minou*. By the 1930s, when she was incorporating fantasy and humour into her work, Albert H. Robson had referred to her as a Montreal landscape painter of note.[31] In 1946 she received the Jury II Prize for *Old Towers* at the Art Association of Montreal spring exhibition. Always interested in new developments, Lockerby by mid-career was painting landscapes in a vibrantly coloured abstract style.

In her late forties Lockerby posed for Prudence Heward's *At the Café*, a portrait that captures her independence and strength of character. She

Mabel Lockerby
Marie and Minou, n.d.
Oil on canvas
76.7 x 66.7 cm
National Gallery of Canada
Purchased 1929

Mabel Lockerby
Old Towers, n.d.
Oil on canvas
60.8 x 51.4 cm
Art Gallery of Hamilton
Director's Purchase Fund, 1958

Mabel Lockerby
The Haunted Pool, n.d.
Oil on cardboard
50.3 x 60.8 cm
National Gallery of Canada
Purchased 1948

remained single but had a lifelong relationship with her cousin Ernest McKnown, who, although they never lived together, claimed they had been secretly married before he left to serve in the First World War.

In spite of failing eyesight in her later years, Lockerby remained spry and a keen Montreal Canadiens fan until she died at the age of ninety-four on May 1, 1976.

Henrietta Mabel May (1877–1971)[32]

The lively and energetic "Henry" was born to Evelyn Henrietta Walker and Edward May, a self-made man who became the mayor of Verdun and a successful real-estate developer. Once he prospered, he moved his family up the hill to the more prestigious Westmount.

May was among the first to enroll in the Art Association of Montreal in 1902. In her mid-twenties at the time, she had delayed her education to help with her nine younger brothers and sisters. In 1912, after completing her studies with Alberta Cleland and William Brymner at the Art Association, she and Emily Coonan travelled to France, England, and Holland, where they visited galleries, studied, and painted. Upon returning to Montreal, she lived with her family at 434 Elm Avenue, set up a studio at 745 St. Catherine Street West, and spent her summers painting at the family cottage in Hudson. Anne Savage recalled:

She was a brilliant figure at the gallery. She painted with such vigour and strength — gay, rhythmic colour using the impressionist's technique of scintillating colour. She spent some time in France, came back radiant — she loved life — painted in the landscapes of the Eastern Townships where she built up her singing happy pictures.[33]

H. Mabel May, 1931
Photo by Melvin Ormond Hammond
21.4 x 15.9 cm
NGC Library
60442

The National Gallery bought four of her works between 1913 and 1924 and several more later. Commissioned by the Canadian War Memorials Fund to record the home front during the First World War, May painted a large six-by-seven-foot canvas entitled *Women Making Shells*, the unusual scene of women working alongside men in a munitions factory. She was paid the then remarkable wage of $250 a month.

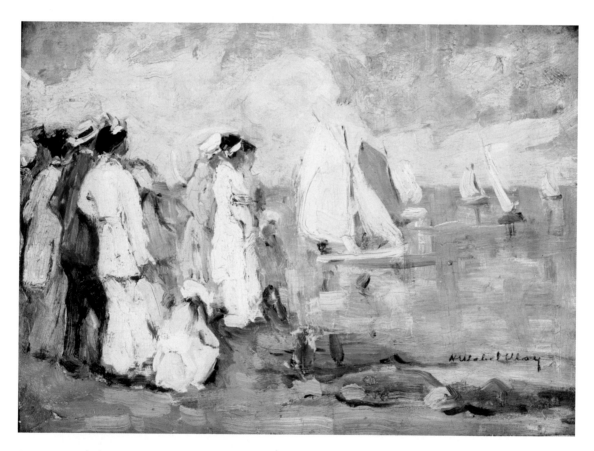

Henrietta Mabel May
Yacht Racing, 1914
Oil on board
22.2 x 26.7 cm
Collection of the Leonard & Bina Ellen Art Gallery, Concordia University
Max and Iris Stern Acquisition Fund
995.08

Henrietta Mabel May
The Three Sisters, c. 1915
Oil on canvas
67.3 x 77.2 cm
Beaverbrook Art Gallery
Gift of Lord Beaverbrook

Henrietta Mabel May
In the Laurentians, n.d.
Oil on canvas
56.2 x 69 cm
National Gallery of Canada
Purchased 1921

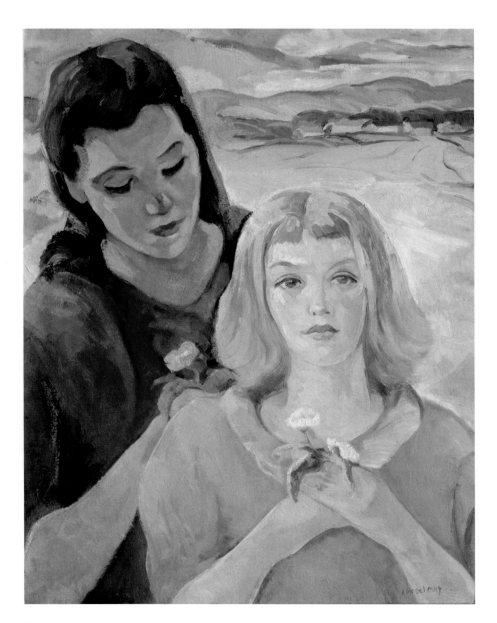

Henrietta Mabel May
Violet and Rose, c. 1920
Oil on canvas
71 x 61 cm
Private Collection, Ontario

In 1915 she was elected an associate of the Royal Canadian Academy, and in 1920, together with Randolph Hewton, Edwin Holgate, and Lilias Torrance Newton, she founded the Beaver Hall Group.

Early paintings such as *Yacht Racing* and *The Three Sisters* show influences of Impressionism, whereas landscapes after 1920 are marked by the style of the Group of Seven. She painted with her friends in the Eastern Townships, New England, and Baie St. Paul in the Lower St. Lawrence area. During the early 1920s Albert Laberge, the art critic for *La Presse*, placed her in the highest ranks of Montreal painters and praised her powerful originality, strong talent for colour, and craftsmanship.[34] In 1929 May received honourable mention in the National Gallery's prestigious Willingdon Arts Competition for *Melting Snow*. Her mature works become increasingly more linear, rhythmical, and simplified in colour.

In the late 1930s May joined a small religious group called I AM, The Foundation of St. Germain. One of its tenets was that colours had spiritual significance. It is thought that she may have avoided strong darks like black and red because they were deemed to have a negative effect.[35]

The Depression brought with it financial problems. The family sold the cottage, and May began teaching to support herself. She continued to exhibit regularly, organized sketching classes in the Eastern Townships, and participated in the founding of the Atelier in 1931 and the Canadian Group of Painters in 1933. Eventually she found a permanent position teaching art history at Elmwood, a private girls' school in Ottawa. From 1938 to 1947 she showed her work with a group called Le Caveau and ran the very successful

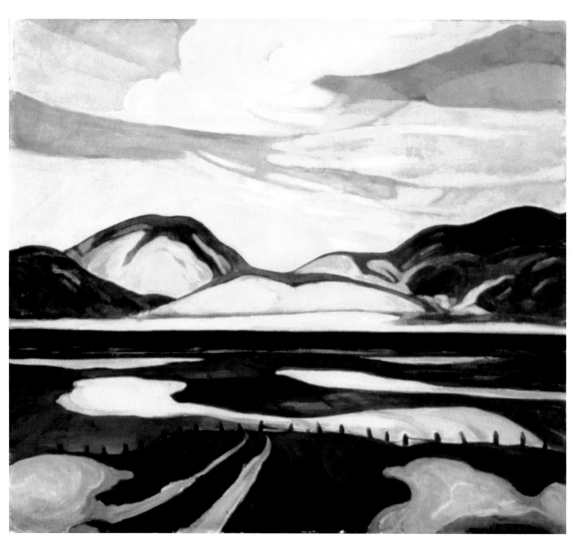

Henrietta Mabel May
Melting Snow, c. 1925
Oil on canvas
91.8 x 101.8 cm
National Gallery of Canada
Purchased 1929

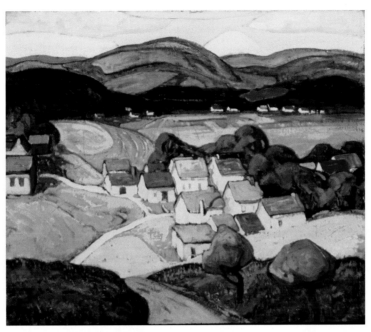

Henrietta Mabel May
The Village, 1925
Oil on canvas
66.6 x 77.1 cm
National Gallery of Canada
Purchased 1926

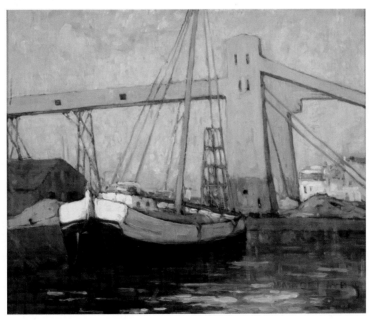

Henrietta Mabel May
Scène du port de Montréal, 1930
Oil on canvas
45.7 x 56.2 cm
Musée d'art contemporain de Montréal
Collection Lavalin
Photo: Richard-Max Tremblay
A 92 793 P1

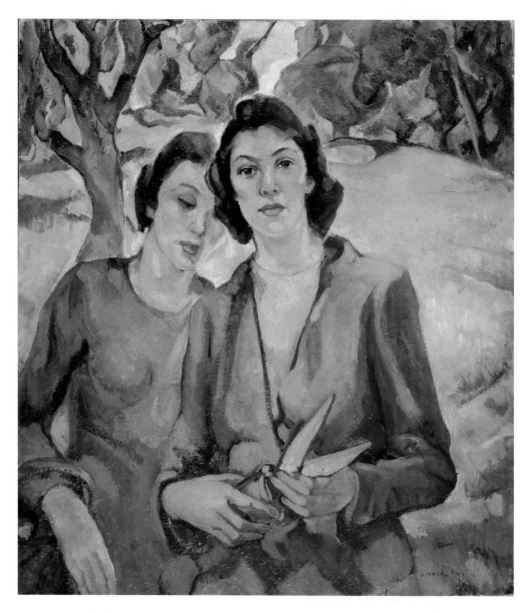

Henrietta Mabel May
Summertime, c. 1935
Oil on canvas
102.2 x 91.6 cm
Musée national des beaux-arts du Québec
Photo: Patrick Altman
51.169

Saturday morning "Happy Art Class" at the National Gallery. The *Ottawa Citizen*'s review of a solo exhibition at James Wilson & Co in 1939 noted:

> Miss May is interested in form and rhythm perspective rather than in the more external manifestations of nature. There is a sweep to most of her landscapes and a skilful arrangement of mass and colour. Some are somber in tone and others are bright, but all have a notable unity in conception and manage to suggest the essential nature of the scenes depicted.[36]

In 1948 she returned to Montreal, where she continued to teach privately until 1950 when she moved to Vancouver to be near her sisters. At the time the *Toronto Star* referred to her as the Emily Carr of Montreal.[37] She rented a studio, taught one or two pupils, and, apart from an exhibition in 1952 at the Vancouver Art Gallery, lived a quiet and secluded life.

May died in Vancouver at the age of ninety-four on October 8, 1971. Robert Ayre's description written twenty years earlier serves as a fitting tribute: "She has always been a joyous painter, taking pleasure in people as well as light and landscape."[38]

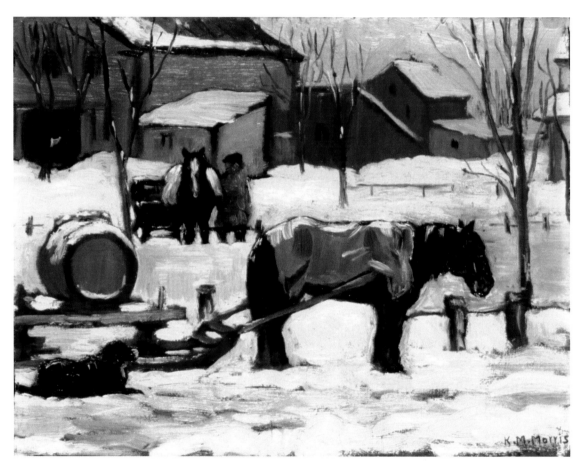

Kathleen Morris
Waiting, n.d.
Oil on panel
26.7 x 34.2 cm
National Gallery of Canada
Purchased 1924

Kathleen Morris (1893–1986)

Kathleen Moir Morris was born into Montreal's Protestant elite in 1893. Encouraged by a doting mother who was a staunch defender of women's rights, "Kay" Morris energetically pursued her studies in spite of a handicap that impaired her speech and coordination.

Armed with a lively sense of humour and much self-confidence, Morris was determined to live a life of joy rather than of despair. She attended the Misses Gardiners' private school and from 1907 to 1917 studied with Brymner and Maurice Cullen at the Art Association of Montreal. Her mother's cousin, the portrait painter Robert Harris, also took an active interest in her career.

Although her father, Montague John Morris, died in 1914, she and her three brothers seem not to have suffered much economic hardship. From 1922 to 1929 Morris lived at 172 O'Connor Street in Ottawa with her mother, Eliza Howard (Bell). Their friend Eric Brown, the director of the National Gallery, saw to it that one of her works was purchased for its collection.

Morris had joined the Beaver Hall Group in 1920, and even after leaving Montreal, she continued to participate in their exhibitions as well as those of the Canadian Group of Painters.

In Ottawa, she delighted in the vitality of the nearby market and painted it frequently. In the winter, accompanied by her mother, she would take sketching trips to Quebec City, the Laurentians, or Berthierville, where they would usually spend six weeks each year. It was there that Morris painted

After High Mass, Berthier-en-Haut, one of the many depictions of her favourite subjects — snow, horses, a town centre with church and buildings. In a letter to J. Russell Harper she recalled the thrill of the scene: "I saw all those horses in front of the nice old church. Sometimes there were as many as three hundred all with different coloured blankets."[39] In 1980, *McGill Cab Stand, 1927* with its horse-drawn sleighs was chosen for a series of Christmas

Kathleen M. Morris, 1930
Photo by Melvin Ormond Hammond
21.3 x 16.3 cm
NGC Library
63006

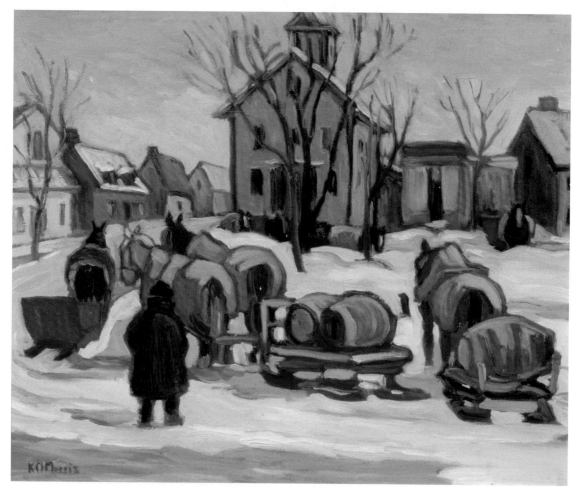

Kathleen Morris
Waiting at the Old Church, Berthierville, Québec, c. 1924
Oil on canvas
50.8 x 61 cm
Private Collection, Ontario

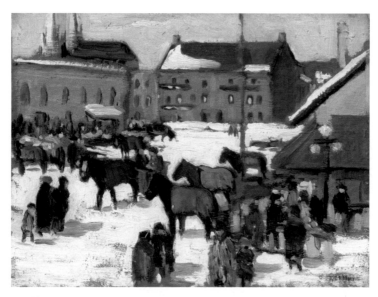

Kathleen Morris
Market Day, Ottawa, 1924
Oil on panel
25.4 x 36.8 cm
Private Collection, Ontario

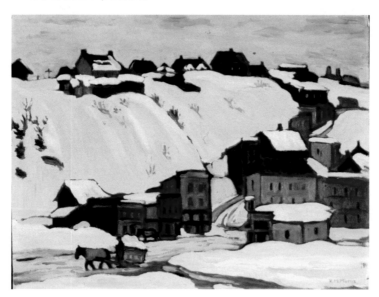

Kathleen Morris
Point Levy, Québec, c. 1925
Oil on canvas
45.8 x 61.2 cm
National Gallery of Canada
Purchased 1926

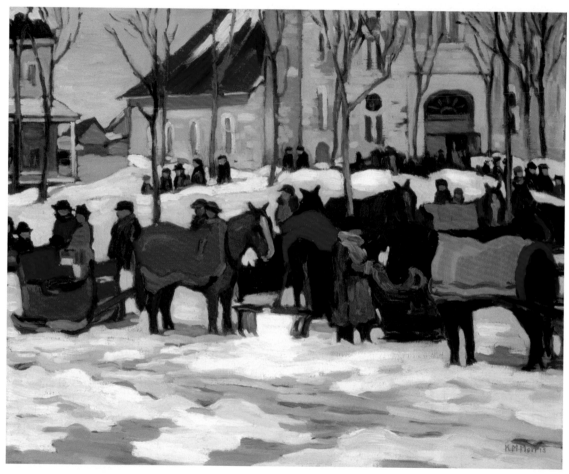

Kathleen Moir Morris
After High Mass, Berthier-en-Haut, 1927
Oil on canvas
61 x 71 cm
Purchase, gift of William J. Morrice
Coll: The Montreal Museum of Fine Arts
Photo: Brian Merrett, MMFA
1927.479

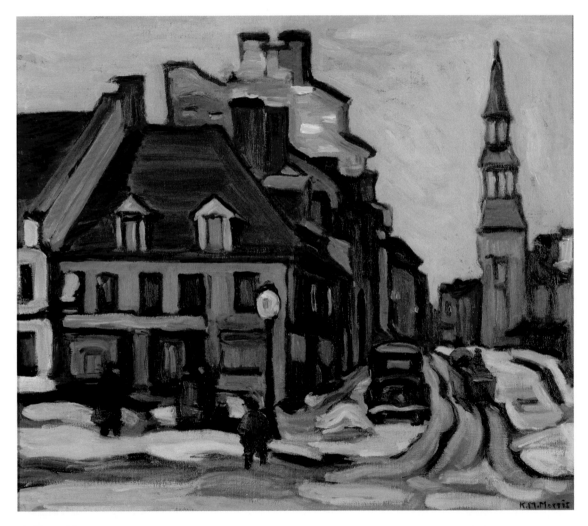

Kathleen Morris
Maison Calvet, St. Paul Street, c. 1930
Oil on canvas
51 x 61 cm
McCord Museum of Canadian History, Montreal
Notman Photographic Archives
M999.77.1

postage stamps. Although few of her paintings are dated and titles are often used more than once, the horses, old streetcars, market scenes, sleighs, and nuns are nostalgic reminders of a former time.

Simplified forms and bold brush strokes of vibrant colour mark her style. W.G. Constable, in his assessment of the Beaver Hall exhibition at the 1937 Royal Institute Galleries in London, singled out Morris as an outstanding example of the second generation of Impressionists.[40] Reviewing the Montreal Arts Club show in 1962, Dorothy Pfeiffer wrote:

> Her solidly composed souvenirs of Old Montreal and its environs should be collectors' treasures. Particularly remarkable is the woman painter's sense of joie de vivre; her clever use of dabs and dashes of brilliant orange-red livens every canvas. … Such painting brings peace to the soul. It is humane, it is technically authoritative, it is the personal expression of joy of life and of tangible emotion by a gifted, forthright, fearless artist.[41]

Upon returning to Montreal in 1929, the family lived on Ridgewood near St. Joseph's Oratory, a neighbourhood from which Morris often drew inspiration. Throughout her life, she spent two months of every summer in Marshall's Bay near Arnprior, Ontario, at the small secluded cottage that had been in the family for over a hundred years. There she would paint the

fields and sunsets or indulge her love for animals by painting cows and sheep. However, since exhibitors preferred her town rather than country scenes, most of her time was spent developing her winter sketches into larger canvases.

Severely handicapped and unable to paint in later years, Morris became involved in the prevention of cruelty to animals. She wrote letters to the press protesting the seal hunt and decried the wearing of furs. When she was eighty, a retrospective exhibition at the Walter Klinkhoff Gallery in Montreal gave her much pleasure and enhanced her reputation.

She spent her last days in a nursing home in Rawdon, Quebec, where she died at the age of ninety-three in December 1986.

Lilias Torrance Newton (1896–1980)

In many ways the witty and sophisticated Lilias Torrance Newton was ahead of her time. Rumour had it that she married on condition that she could spend three months of the year studying in Paris. She divorced when divorce was frowned upon, raised a child on her own, and supported herself as a portrait painter in a traditionally male profession.

Torrance Newton's parents, Alice Mary Stewart and businessman Forbes Torrance, were prominent Montrealers. Her father, who died before her birth, was a member of the Pen and Pencil Club of Montreal, and it is thought that his old sketchbooks were her first inspiration. As a child she attended a local private school run by Rev. Hewton, father of the artist Randolph Hewton, and at the same time took classes at the Art Association of Montreal with Alberta Cleland. In 1910 she entered Miss Edgar's and Miss Cramp's, a prestigious girls' school where she was a student of artist Laura Muntz Lyall. At sixteen she left to study full-time with William Brymner at the Art Association.

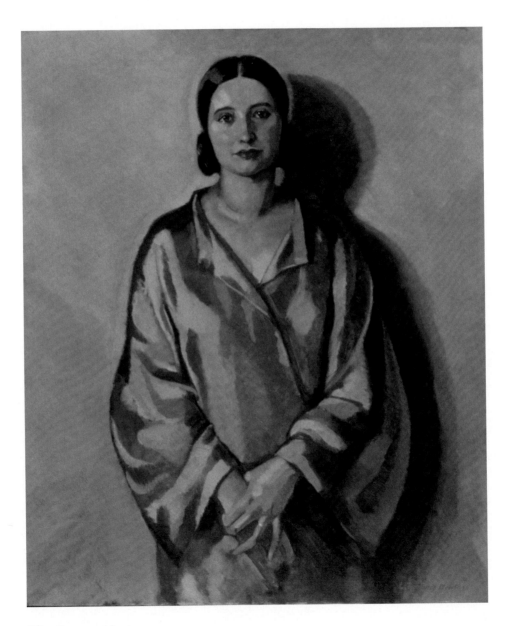

Lilias Torrance Newton
Portrait of Madame Lily Valty, n.d.
Oil on canvas
101.6 x 86.4 cm
Collection of Glenbow Museum, Calgary, Canada
Gift of the Devonian Foundation, 1979

Accompanied by her mother, she moved to England during the First World War to help with the Red Cross war effort and to study art with the Modernist Alfred Wolmark. Upon her return in 1919, she established herself as a professional portrait painter. The following year she became a founding member of the Beaver Hall Group, sharing a studio with Henrietta Mabel May and teaching a Saturday morning class for ladies. In 1921 she married Frederick G. Newton, a stockbroker, whom she had met in England when he was a lieutenant in the Canadian army.

She rented a studio on Union Avenue, and although married, visited Paris twice without her husband: once in 1923, when she studied drawing and composition with the Russian Alexandre Jacovleff, and again in 1929. Her son, Francis (the "Winkie" of her paintings), was born in 1926, and by 1927 her unusual lifestyle had attracted the attention of *Saturday Night* magazine, which devoted a lengthy article to the wonder woman who was able to combine the roles of mother, wife, and artist.[42] By 1933 she had divorced her husband, who had been unable to cope with the stock market crash and his consequent financial losses.

Now alone with a child to support, the Depression was a difficult time for Torrance Newton. Economic conditions meant little work in spite of the social connections she enjoyed. Eric Brown, director of the National Gallery, tried to help by commissioning a portrait of himself and recommending her to wealthy patrons. She continued to paint, teach, and participate in the artist community. In 1933 she played a part in the founding of the Canadian Group of Painters, and from 1934 to 1940 she taught portrait painting and still life

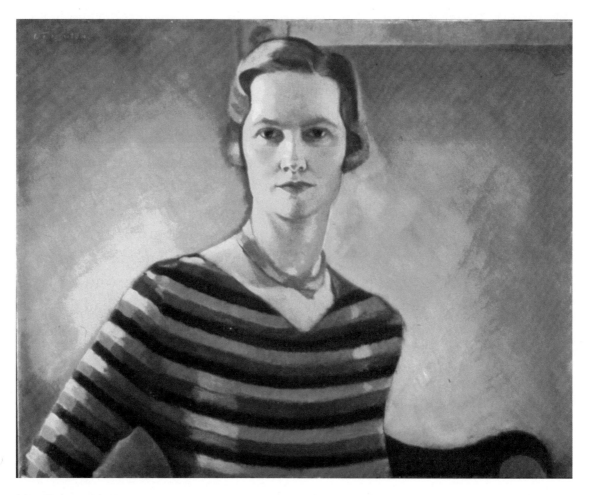

Lilias Torrance Newton
Self-Portrait, c. 1929
Oil on canvas
61.5 x 76.6 cm
National Gallery of Canada
Purchased 1930

Lilias Torrance Newton
Study for *Winkie*, c. 1929
Oil on canvas
55.9 x 50.8 cm
Coll: Laura and Byrne Harper

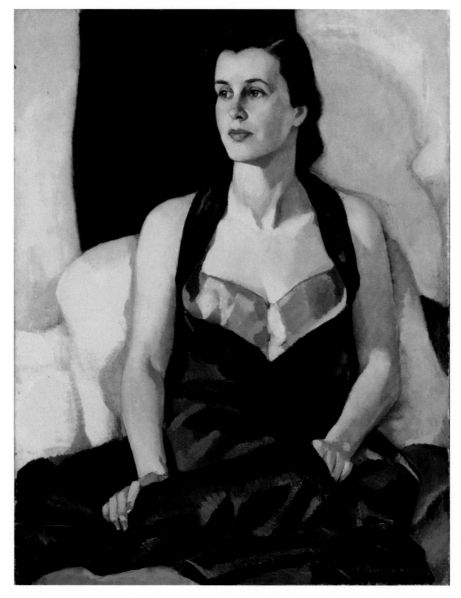

Lilias Torrance Newton
Lady in Black (portrait of Mrs. Albert Henry Steward Gillson), c. 1936
Oil on canvas
91.8 x 71.3 cm
Purchase, William Gilman Cheney Bequest
Coll: The Montreal Museum of Fine Arts
Photo: Brian Merrett, MMFA
1939.699

with Edwin Holgate at the Musée des Beaux Arts. At an exhibition in 1934 the Art Gallery of Toronto refused to hang *Nude in a Studio* because the subject wore opened-toed green shoes and was therefore considered "offensively naked rather than artistically nude."[43] Or was it, as Donald W. Buchanan suggested in his scathing article in the *Canadian Forum,* because the model was Russian and did not have the great outdoors as a canopy?[44]

Torrance Newton slowly gained recognition by travelling across the country and painting portraits of Canada's elite — the Masseys and the Southams or her artist friends — A.Y. Jackson, Lawren Harris, Edwin Holgate, and Arthur Lismer. She was the youngest and the third female member to be elected to the Royal Canadian Academy, an achievement that raised her prestige and increased the demand for her work. During the Second World War the Department of National Defence hired her to paint portraits of Canadian soldiers for recruiting posters. By the late 1940s she was considered one of the best portrait painters in Canada. Commissions began to flow in from governments, universities, boardrooms, and head offices, and by 1952 her fees could be as high as $1,500. In 1957 she became the first Canadian chosen to paint the official portrait of Queen Elizabeth and Prince Philip for Rideau Hall.

Known for her attractiveness, lively conversation, and gracious manners, she quickly established a rapport with her subjects. One of her sitters wrote, "How much we have enjoyed your presence during these ?18? [sic] sittings! I can't tell you how nice it was for me. You fit so beautifully (and ornamentally!) into so many circles. I feel sorry that having found you we (in a sense) lose you."[45]

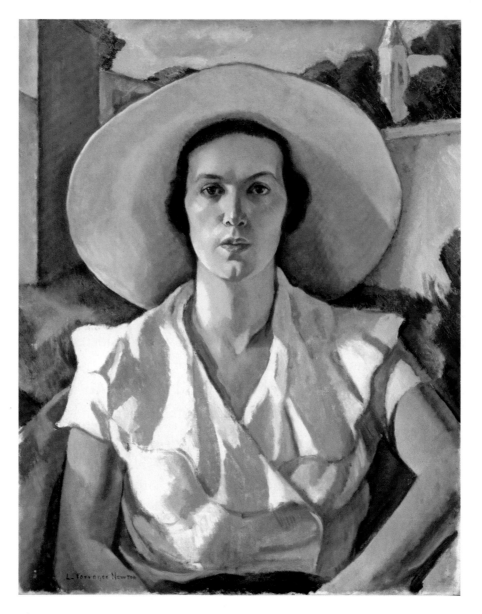

Lilias Torrance Newton
Martha, c. 1938
Oil on canvas
76.7 x 61.4 cm
Musée national des beaux-arts du Québec
Photo: Jean-Guy Kérouac
40.13

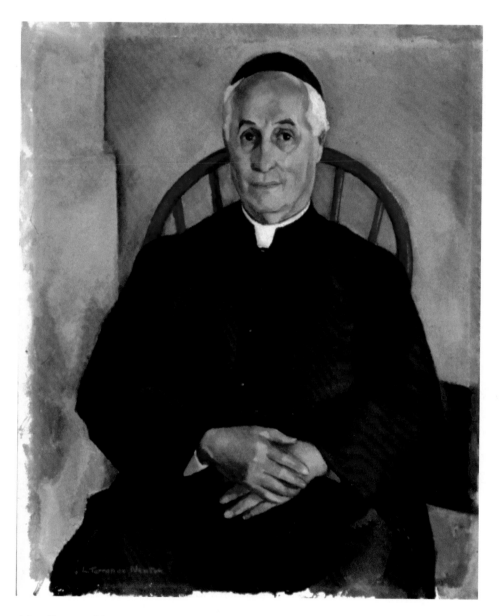

Lilias Torrance Newton
Portrait of Frère Adélard, 1939
Oil on canvas
91.6 x 76.4 cm
National Gallery of Canada
Gift of Alan D. McCall, Montreal, and Dr. G.R. McCall, Montreal, 1982

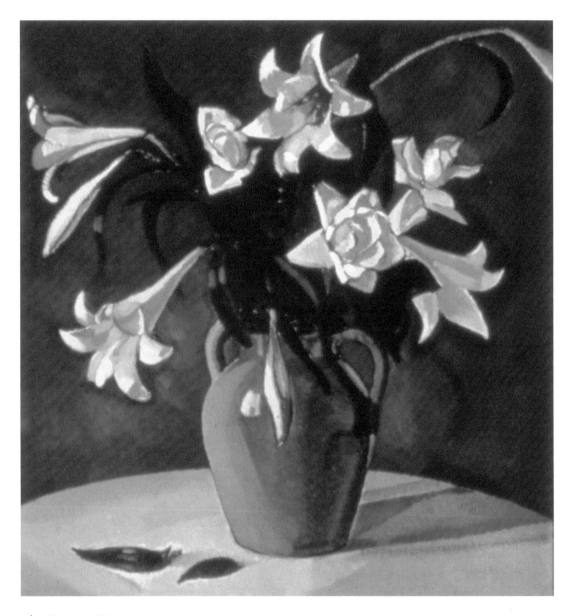

Lilias Torrance Newton
Still Life of Lilies, c. 1940
Oil on canvas
64.0 x 62.0 cm
Collection of the Agnes Etherington Art Centre, Queen's University, Kingston
Purchase, Chancellor Richardson Memorial Fund and Wintario matching grant, 1979
22-040

An exceptional technical skill enabled her to emphasize character without taking away from the likeness of her subjects. She used pose, gesture, clothing, colour, symbolic background, and compositional arrangement to reveal the individuality of the sitter. Her personal preference was to paint women: "Women's characters appear more definite, even though they are more subtle. There is more colour to work with, and I feel I can paint a more imaginative portrait of a woman, because of her clothes, through which she expresses herself."[46] Unlike the prevailing portraiture at the time, her works tend to be informal with no attempt to flatter the subjects.

For thirty years Torrance Newton dominated Canadian portraiture. Success brought her the financial freedom to travel and a luxury penthouse with a thirty-foot studio and a view of Mount Royal in the Linton Apartments on Sherbrooke Street. In spite of struggles with depression throughout her life and later deafness, she continued to paint until 1975. She died five years later in a Cowansville, Quebec, nursing home.

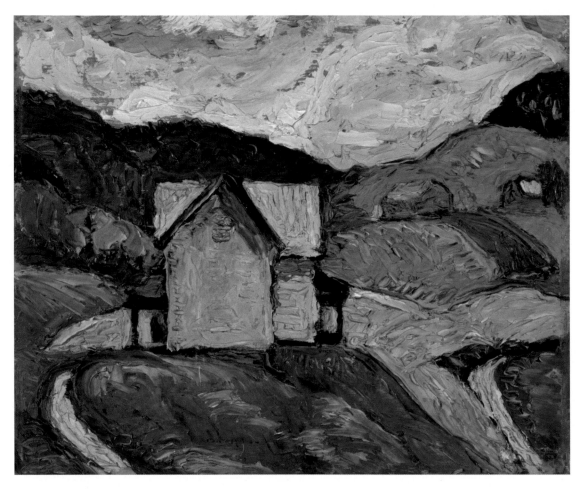

Sarah Robertson
Eastern Townships, n.d.
Oil on panel
29.2 x 34.4 cm
Collection of the Agnes Etherington Art Centre, Queen's University, Kingston
Bequest of Basil Nares in memory of Prudence Heward and her sister Gladys Heward, 1981
24-023

Sarah Robertson (1891–1948)

Why Sarah Margaret Armour Robertson never married her soldier suitor has been the subject of much speculation. She shared an apartment at 1470 Fort Street with a domineering mother who spent her life mourning a son lost in war.

Although part of Montreal's English establishment, Sarah lived most of her life in genteel poverty. Her parents were Jessie Ann Christie and John Armour Robertson, who early on provided his family with the comforts of the privileged class. There was schooling by a family governess and a country house with ponies in Chambly, but by the 1920s the income from the Robertsons' wholesale dry goods business seems to have dwindled.

From about 1909 to 1924 Robertson attended the Art Association of Montreal, where she studied with William Brymner and Maurice Cullen, but unlike many of her fellow students, she did not visit or study in Europe. She was a highly regarded member of the Beaver Hall Group and later of the Canadian Group of Painters. Ill health limited her output

to two or three canvases a year. A letter written in 1931 to Eric Brown, director of the National Gallery, gives a sense of her difficulties in gaining recognition: "If it had not been for you and the Group of Seven … I would surely be sunk in oblivion."[47]

She painted portraits, still lifes, and murals for private houses, but was primarily interested in landscapes. Idyllic childhood days at the family country house, frequent visits with her close friend Prudence Heward at Fernbank, with Nora Collyer in the Eastern Townships, and with family friends in Stowe, Vermont, inspired her work. There were often sketching trips with A.Y. Jackson, Heward, Seath, and Collyer to the Laurentians, the Lower St. Lawrence region, or to Nova Scotia. Near her home in the city she found more subject material: hollyhocks in a garden, views from her window, and city landmarks such as the old fort depicted in *Fort of the Sulpician Seminary*. In a tribute to Robertson in 1949, A.Y. Jackson wrote,

Sarah Robertson sketching outdoors, n.d.
Photo
16.5 x 16.7 cm
NGC Library
63093

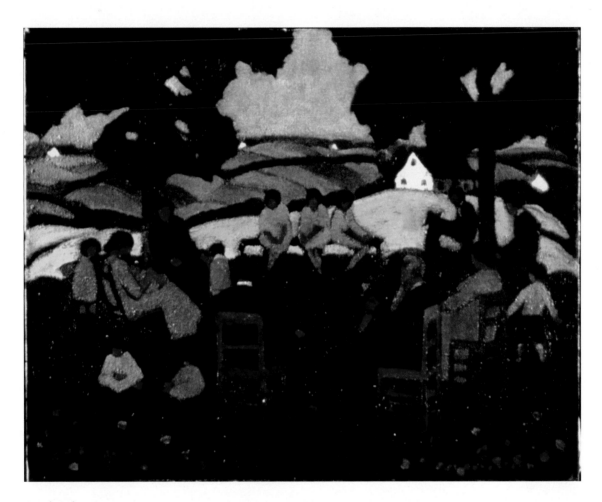

Sarah Robertson
Le Repos, c. 1926
Oil on canvas
61.4 x 76.8 cm
National Gallery of Canada
Purchased 1927

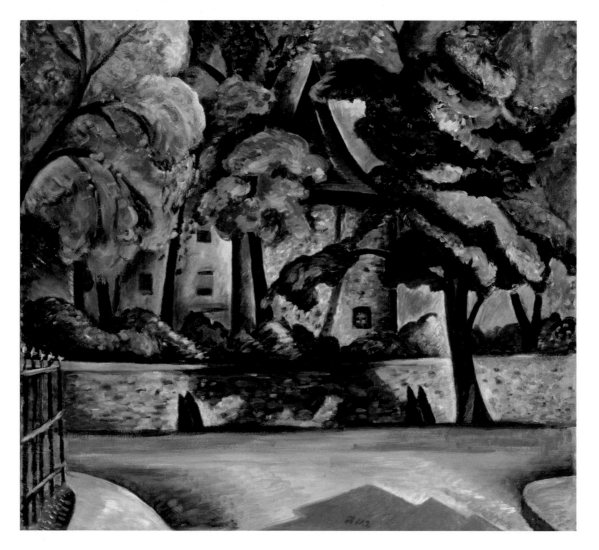

Sarah Robertson
Fort of the Sulpician Seminary, c. 1931
Oil on canvas
61.2 x 66.5 cm
Purchase, William Gilman Cheney Bequest
Coll: The Montreal Museum of Fine Arts
Photo: Brian Merrett, MMFA
1943.812

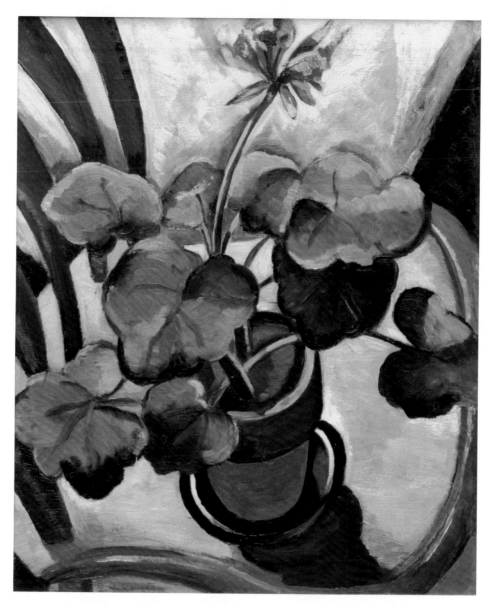

Sarah Robertson
Still Life on a Chair, c. 1930s
Oil on canvas
35.6 x 45.7 cm
Coll: Laura and Byrne Harper

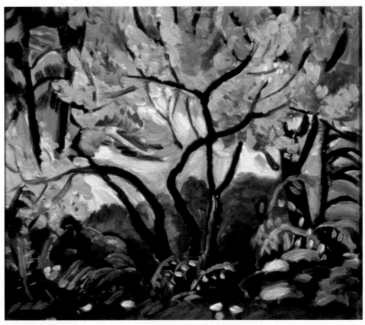

Sarah Robertson
Spring in the Orchard, n.d.
Oil on panel
29.6 x 34.6 cm
Collection of the Agnes Etherington Art Centre, Queen's University, Kingston
Bequest of Basil Nares in memory of Prudence Heward and her sister Gladys Heward, 1981
24-025

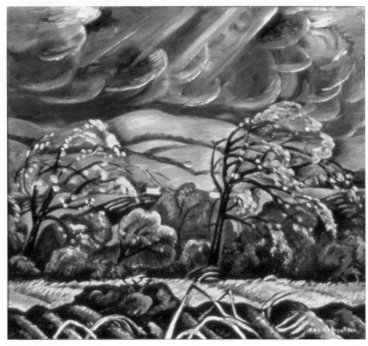

Sarah Robertson
Storm Como, n.d.
Oil on canvas
63.5 x 71.5 cm
Collection of the Agnes Etherington Art Centre, Queen's University, Kingston
Purchase, Chancellor Richardson Memorial Fund and Wintario Funds, 1978
21-029

"Among the talented students who worked under William Brymner in Montreal, Sarah Robertson was one with outstanding ability. She developed a very personal form of expression, mostly in landscape with figures and paintings of flowers."[48]

Robertson was noted as a colourist who at times used black for dramatic effect. In 1929 Henri Girardin in *La Revue Moderne* described her work as "clearly violent, yet very decorative and absolutely off the beaten track"[49] As she matured, her painting became freer and bolder. Arthur Lismer noted her Modernist tendencies: "She has the courage to create landscapes and not copy them literally."[50]

The gay and vivacious Robertson was a constant source of knowledge, advice, and support for the Beaver Hall Group. Her close friend Prudence Heward regularly sought her opinion, as did A.Y. Jackson, when selecting exhibition pieces. Difficulty walking due to illness caused her to discontinue outdoor sketching in her last years. Nevertheless, she retained her sense of humour and enjoyed the companionship of many friends. She died in Montreal at the age of fifty-seven in 1948. In the introduction to the National Gallery's memorial exhibition, A.Y. Jackson wrote that Robertson was "the good artist, interested above all else in art, and not too much concerned with ideologies or about the artist's mission in life."[51]

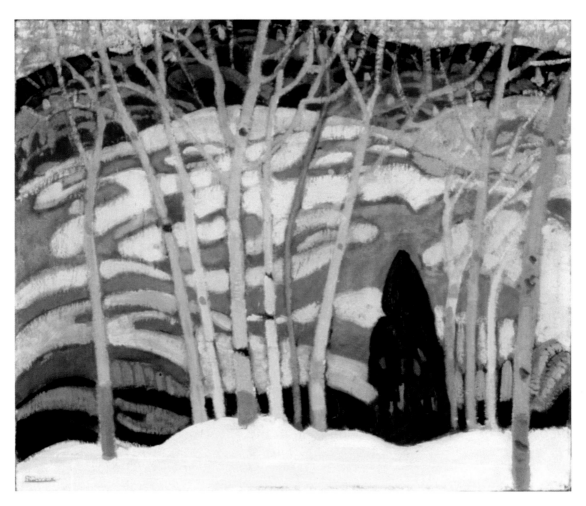

Anne Savage
April in the Laurentians, c. 1922-1924
Oil on canvas
50.9 x 61.5 cm
National Gallery of Canada
Gift of Anne McDougall, Ottawa, 1997

Anne Savage (1896–1971)

"Give that girl a chance and she would be one of the finest painters in Canada," Arthur Lismer declared upon seeing *The Plough* at a Group of Seven exhibition in 1931.[52]

Anne Douglas Savage belonged to an important Montreal family that included John Galt, the Scottish novelist and founder of Guelph, Ontario, and Sir Alexander Galt, a father of Confederation. She was the daughter of Helen Lizars Galt and John George Savage, who had inherited Albert Soaps. During the First World War, a short time after the business failed, the family moved from their large country house in Dorval to 4090 Highland Avenue, where Savage would live for the rest of her life.

Upon graduating from the High School for Girls, Savage attended the Art Association of Montreal until 1919. She studied with Maurice Cullen and William Brymner, often joining their sketching trips to the surrounding countryside. Her first employment was as a medical artist at the

military hospitals in Montreal and Toronto. Accompanied by a colleague, she later set out for Minneapolis, where she took classes at the School of Design. Returning to Montreal in 1920, she worked as a commercial artist with Ronald's Press, and, eager to continue her painting, joined the Beaver Hall Group.

The family's financial security ended when her father died in 1922, leaving Savage to provide for her mother. She chose to teach art, a career she embraced enthusiastically. It gave her the financial freedom to do what she liked: she painted, travelled, built her own studio near the family's cottage in the Laurentians, and chose not to marry her long-time mentor, A.Y. Jackson.

Savage was well known for her tireless contribution to the community. From 1922 to 1952 she worked first as a teacher at Baron Byng High School and then as a supervisor of art for the Montreal Protestant School Board. In 1927 at the request of the National Gallery she visited the Skeena River area, where she painted a number of sketches as part of an effort to conserve the aboriginal culture in British Columbia. She helped found Atelier, a

Savage, Anne
Photo
Courtesy of Leah Sherman

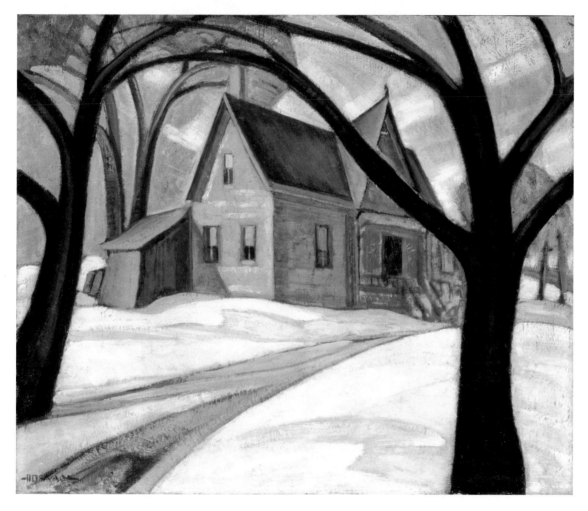

Anne Savage
La Maison Rouge, Dorval, c. 1928
Oil on canvas
51 x 61.7 cm
Musée national des beaux-arts du Québec
Photo: Jean-Guy Kérouac
95.11

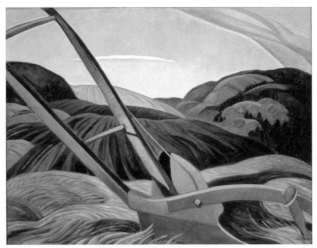

Anne Savage
The Plough, 1931-1933
Oil on canvas
76.4 x 102.3 cm
Gift of Arthur B. Gill
Coll: The Montreal Museum of Fine Arts
Photo: Brian Merrett, MMFA
1970.1652

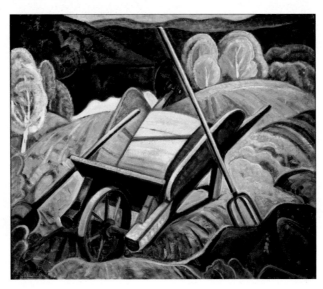

Anne Savage
The Wheelbarrow, Wonish, c. 1935
Oil on canvas
63.5 x 76.2 cm
Coll: Laura and Byrne Harper

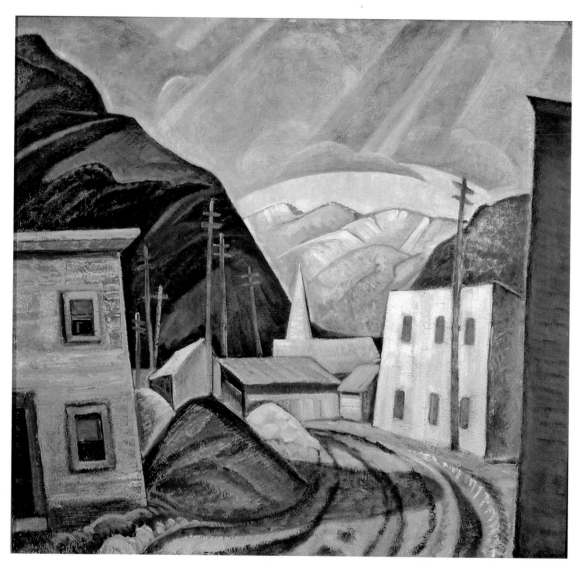

Anne Savage
Northern Town, Banff, c. 1938
Oil on canvas
66.8 x 71 cm
McCord Museum of Canadian History, Montreal
Notman Photographic Archives
M985.160

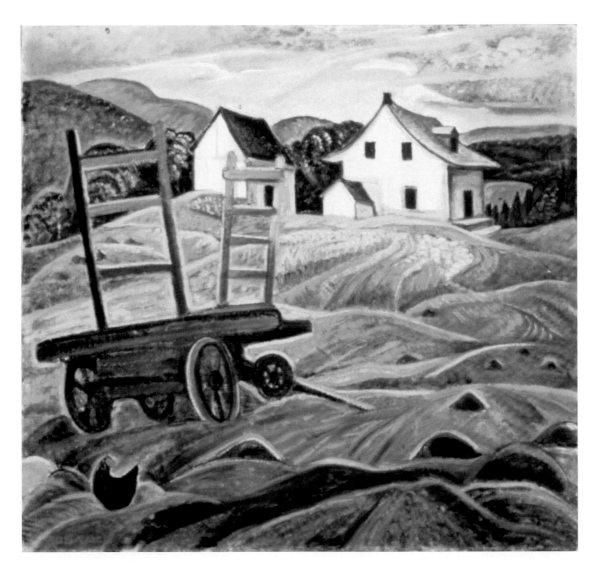

Anne Savage
After Rain, 1941
Oil on canvas
56.1 x 61 cm
National Gallery of Canada
Purchased 1948

school of modern art in Montreal in 1931, and the Canadian Group of Painters in 1933.

Recognized for her child-centred approach to teaching, Savage was instrumental in the development of art education. In the 1930s she organized Saturday morning classes at the Art Association of Montreal and gave CBC radio broadcasts on art that inspired many, especially women looking for a role model. After retirement she continued to lecture, taught at McGill, and played a major part in the founding of the Child Art Council, which later became the Quebec Society for Education through Art.

Predominantly a landscape painter, Savage was early on influenced by of the Group of Seven, but she developed her own, very personal, style. She focused on creating a mood and "simple statements of things I have seen."[53] Robert Ayre, art critic of the *Montreal Star*, wrote, "There is never any fussiness of detail. If she puts a plough into a landscape or a wheelbarrow it looks like a workable implement as well as a substantial part of the design."[54] The Dorval country home, childhood holidays in Métis, and summer vacations in the Eastern Townships or at the Lake Wonish cottage provided her with subject material.

A muted use of colour, skillful design, rhythmic tension, and contrasts of mass and space mark her work. She was always eager to experiment, whether it was with gesso whitened masonite, with acrylic paints, or the new trend towards abstraction, as in *Yellow Days, Lake Wonish*. In later years, she turned from painting landscapes to still lifes, window views, and family portraits. Fellow artist Edwin Holgate notes, "Toward the end of her life you

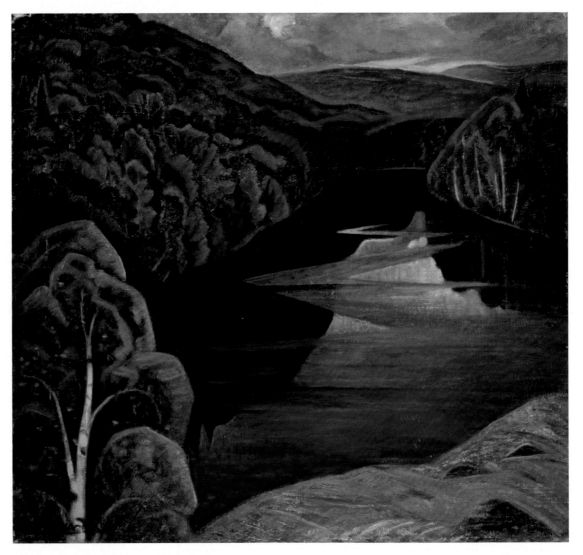

Anne Savage
The Lake at Evening, c. 1943
Oil on canvas
56.20 x 61.00 cm
Purchase, Robert Lindsay Fund
Coll: The Montreal Museum of Fine Arts
Photo: Brian Merrett, MMFA
1944.857

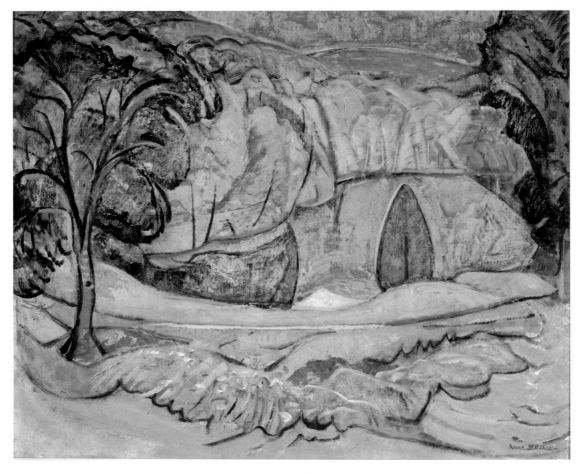

Anne Savage
Yellow Days, Lake Wonish, 1960
Oil on masonite
82.6 x 105.6 cm
Musée d'art contemporain de Montréal
Collection Lavalin
Photo: Centre de Documention Yvan Boulerice
A 92 854 P1

could see a spiritual change. She pitched the colour high, used lots of pinks and yellows, became more abstract."[55]

Of a deeply compassionate nature, Savage always found time to care for others. She opened her home to refugees during the war, looked after her dying mother, and later nursed Margaret English (Gee-Gee), a bedridden childhood nanny.

In 1969 former students honoured their "magnetic and inspirational" teacher with a retrospective at Sir George Williams University. She died two years later on March 25, 1971. Barbara Meadowcroft wrote, "Anne Savage believed in art as the expression of what was highest in the human spirit. Whether she was painting or awakening others to the beauty around them, she worked with self-abandonment, intensity and joy."[56]

Ethel Seath (1879–1963)

Like Emily Coonan, Ethel Seath did not grow up in the English Protestant elite of Montreal. Her father's business as an importer of leather goods failed, her parents separated, and Ethel was obliged to help support her four brothers and sisters.

Her parents, Norman Alexander Seath and Lizetta Annie Foulds, parted when she was in her late teens. With her father gone, Ethel, the eldest of three daughters, felt it was her responsibility to help her mother raise the children. In order to supplement the family income, she decided to pursue a career in textile design.

She began her training in the late 1890s at the Conseil des Arts et Manufactures, a provincial school where for three years she studied drawing with Edmond Dyonnet and lithography with Robert Harris. At the age of sixteen she found a position as an illustrator in the male-dominated newspaper business with the *Montreal Witness*. She moved on to the *Montreal Star* in 1901

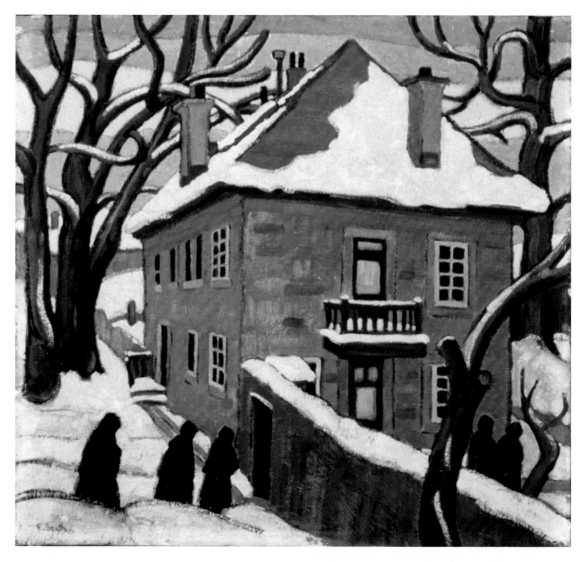

Ethel Seath
The Gardener's House, c. 1930
Oil on canvas
62.5 x 67 cm
National Gallery of Canada
Purchased 1931

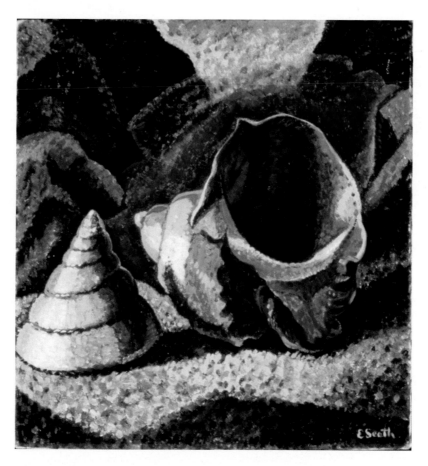

Ethel Seath
Shells, c. 1937
Oil on canvas
51.4 x 48.7 cm
National Gallery of Canada
Purchased 1997 from the Evelyn de Rostaing McMann Fund

Ethel Seath
The White Barn, Eastern Townships, c. 1941
Oil on canvas
71.5 x 86.5 cm
National Gallery of Canada
Purchased 1948

and eventually joined the *Family Herald*. In her spare time she participated in sketching trips and took classes with William Brymner, Edmond Dyonnet, and Maurice Cullen offered by the Art Association of Montreal. Later, there were studies with the well-known American artist and teacher Charles Hawthorne at the Cape Cod School of Art in Provincetown, Massachusetts.

After twenty years as an illustrator, she was invited to teach art at The Study, a private girls' school in Montreal. The founder, Margaret Gascoigne, became her lifelong friend. Of contrasting personalities, they shared similar philosophies on education and devoted their lives to the school. Against the rigid conservatism of the Victorian approach to teaching art, Seath sought to develop a child's innate creativity and to keep up with new trends. She once said, "One can teach how to mainly paint or draw, but one can't be taught to put an individual's spirit into a picture, that comes from deep within."[57]

Seath was a member of the Beaver Hall Group, the Contemporary Art Society, and the Canadian Group of Painters. During the difficult times of the Depression when The Study's continued existence was in jeopardy, she took on the additional responsibility of teaching the Art Association's Saturday morning class, which had been set up by Anne Savage.

In spite of working full-time, Seath continued to paint and exhibit throughout her life. Her earliest works are pen and paper sketches in black and white. In 1925, she contributed the woodcut illustrations for Margaret Gascoigne's *Chansons of Old French Canada*. Visits to the Lower St. Lawrence region, summer holidays in the Eastern Townships, and trips to Nova Scotia

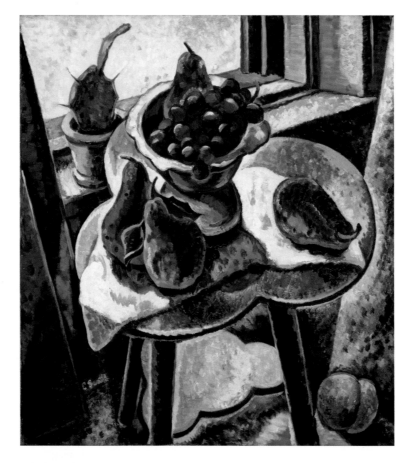

Ethel Seath
Pears in a Window, before 1944
Oil on canvas
63.5 x 61.2 cm
Purchase, Robert Lindsay Fund
Coll: The Montreal Museum of Fine Arts
Photo: Brian Merrett, MMFA
1944.858

with Nora Collyer and Sarah Robertson inspired her landscape and harbour scenes. During the Second World War she painted *Munitions Plant, Montreal* as part of the government's home front art project. Her later cityscapes and still lifes such as *Undergrowth* are marked by curvilinear patterns, bold masses of colour, and simplified detail. Robert Ayre, reviewing her 1962 show at the Montreal Museum of Fine Arts for the *Montreal Star*, wrote, "Miss Seath's first concern is with colour and design. She gets them both from the earth and the fruits of the earth…. But while she clings to the things she knows and loves, she has a strong sense of their abstract qualities, which she emphasizes especially in some of her still life compositions."[58]

Like so many of the Beaver Hall women, Seath became a caregiver when her mother's health began to fail. She continued to experiment with new painting techniques throughout her life. Seath taught until the remarkable age of eighty-three and died one year after she retired.

A fitting tribute to her appeared in the *Study Chronicle*:

> Ethel Seath died on April 10th, 1963 after a lifetime dedicated to her chosen profession. One of Canada's finest painters, Miss Seath devoted herself to teaching and was never interested in personal fame or recognition. In spite of herself, and of all those wonderful qualities of humility and selflessness, she has left behind her a treasury of paintings which are a lasting memorial to her life as an artist. [59]

Ethel Seath
Undergrowth, 1954
Oil on canvas
50 x 60 cm
Collection Lavalin du Musée d'art contemporain de Montréal
Photo: MACM
A 92 821 P1

Chronology/Exhibitions

ABBREVIATIONS USED IN THE APPENDICES

AAM	Art Association of Montreal
AEAC	Agnes Etherington Art Centre
AGH	Art Gallery of Hamilton
AGO	Art Gallery of Ontario
AGT	Art Gallery of Toronto
AGV	Art Gallery of Greater Victoria
AGW	Art Gallery of Windsor
ARCA	Associate of the Royal Canadian Academy
CAS	Contemporary Art Society
CGP	Canadian Group of Painters
CNE	Canadian National Exhibition
MMFA	Montreal Museum of Fine Arts
NGC	National Gallery of Canada
OSA	Ontario Society of Artists
RCA	Royal Canadian Academy
VAG	Vancouver Art Gallery

NORA COLLYER (1898–1979)

1913	AAM Junior Elementary Class Scholarship
1914	AAM Senior Elementary Class Scholarship
1919	AAM Spring
1920	Robert Reford Prize, AAM
1922	RCA Annual
1930	*Paintings by a Group of Montreal Contemporary Artists*, AAM
1932	*Annual Exhibition of Canadian Art*, NGC
1933	*Exhibition of Paintings by Canadian Group of Painters*, AGT
1936	*Canadian Group of Painters*, AGT, NGC
1937	*Exhibition of Paintings, Drawings and Sculpture by Artists of the British Empire Overseas* (Coronation Exhibition), Royal Institute Galleries, London, England *Canadian Group of Painters*, AGT (AAM 1938)
1939	*Exhibition by the Canadian Group of Painters*, New York World's Fair *Canadian Group of Painters*, AGT (AAM 1940)
1940	*Canadian National Committee on Refugees*, NGC
1942	*Canadian Group of Painters*, AGT, AAM, NGC

1946	Solo, Dominion Gallery, Montreal
1950	*Six Montreal Women Painters*, MMFA
1956	*Inaugural Exhibition of Paintings*, Cowansville Art Centre, Quebec
1964	Solo, Walter Klinkhoff Gallery, Montreal
1966	*The Beaver Hall Hill Group*, NGC & circulating
1971	Solo, *Paintings by Nora F. Collyer*, Kastel Gallery, Montreal
1982	*Women Painters of the Beaver Hall Group*, Sir George Williams Art Galleries, Montreal
1991	*Beaver Hall Hill Group*, Kaspar Gallery, Toronto

EMILY COONAN (1885–1971)

c.1898	Studies at the Conseil des Arts et Manufactures
1905	Enters AAM
1907	AAM Scholarship in Life Class
1908	AAM Spring
1910	RCA Annual
1913	AAM Spring

1914–15 *Canadian Artists Patriotic Fund Exhibition*, RCA Public Library, Toronto & circulating

1914 NGC Travelling Scholarship

1916 Women's Art Society Prize

1920–21 NGC Travelling Scholarship (awarded 1914)

1923–24 *An Exhibition of Modern Canadian Paintings*, Group of Seven U.S. tour

1924 *British Empire Exhibition*, Wembley, England
Pictures Exhibited by the Montreal Group of Artists, Hart House, Toronto

1931 *Annual Exhibition of Canadian Art*, NGC

1933 AAM Spring

1966 *The Beaver Hall Hill Group*, NGC & circulating

1982 *Women Painters of the Beaver Hall Group*, Sir George Williams Art Galleries, Montreal

1987 *Emily Coonan (1885–1971)*, Concordia Art Gallery, Montreal

1997 *Montreal Women Painters on the Threshold of Modernity*, MMFA

2001 *Defining the Portrait*, Leonard and Bina Ellen Art Gallery, Concordia University, Montreal

PRUDENCE HEWARD (1896–1947)

1912	AAM Scholarship in Senior Elementary Class
1914	AAM Spring
1920	AAM Spring
1922–24	AAM Spring
1923	Robert Reford Prize for painting
1924	Women's Art Society Prize for painting Robert Reford Prize RCA Annual
1925	*British Empire Exhibition*, Wembley, England
1925–1926	Study at Académie Calarossi and Ecole des Beaux-Arts, Paris
1926	RCA, AGT
1927	*Exposition d'art canadien*, Musée du Jeu de Paume, Paris
1927–1929	RCA Annual
1927–1933	*Annual Exhibition of Canadian Art*, NGC
1928	*Exhibition of Contemporary Canadian Painting*, AAM *Exhibition of the Group of Seven*, Toronto

1928–29	OSA, Toronto
1929	AAM
	Exhibition of Paintings by the Group of Seven, AGT
	Willingdon Prize for *Girl on a Hill*
	Studies at Scandinavian Academy, Paris
1929	CNE Toronto
1930	*An Exhibition of Paintings by Contemporary Canadian Artists*, Corcoran Gallery of Art, Washington, DC & circulating
	Paintings by a Group of Contemporary Montreal Artists, AAM
	The Art League, Vancouver
1930–32	*Exhibition of the Group of Seven*, AGT
1931	*First Baltimore Pan American Exhibition of Contemporary Paintings*, Baltimore Museum of Art
	Exhibition of the Group of Seven, AGT
	CNE
	AGT
	Exhibition of Canadian Art at the British Empire Trade Exhibition, Buenos Aires
1932	Solo, W. Scott & Sons, Montreal
	Eleven Montreal Artists, W. Scott & Sons, Montreal
	Exhibition of Paintings by Contemporary Canadian Artists, Roerich Museum, NYC
1933	Founding member of Canadian Group of Painters
	Exhibition of Paintings by Canadian Group of Painters, AGT, (AAM 1934)
	Paintings by the Canadian Group of Painters, Heinz Art Salon, Atlantic City

1933–34	*Exhibition of Paintings by Canadian Group of Painters*, AGT
1933-39	Vice-president of Canadian Group of Painters
1934	Three-woman exhibition, Hart House, Toronto and W. Scott & Sons, Montreal
1934–35	CNE
1935	*International Exhibition of Paintings*, Carnegie Institute, Pittsburgh, PA *Loan Exhibition*, AGT OSA Toronto
1935–37	*National Produced in Canada Exhibition*, Sun Life Building, Montreal
1936	RCA *Exhibition of Contemporary Canadian Paintings* (Carnegie Corporation of New York), NGC & circulating *Canadian Group of Painters*, AGT, NGC *Exhibition of Contemporary Canadian Painting for Circulation in the Southern Dominions of the British Empire*, Johannesburg, South Africa *Canadian Group of Painters*
1937	*Group Show of Modernists*, The Arts Club, Montreal *Exhibition of Paintings, Drawings and Sculpture by Artists of the British Empire Overseas* (Coronation Exhibition), Royal Institute Galleries, London, England *International Society of Women Painters and Sculptors*, The Arts Club, Montreal *Exposition Internationale*, Paris *Summer Exhibition*, W. Scott & Sons, Montreal
1937–38	*Canadian Group of Painters*, AGT

1938	*A Century of Canadian Art*, The Tate Art Gallery, London, England
	AAM
	Auction to Aid Spanish Orphanages
	Sale Aid to Spanish Democracy, 2037 Peel Street, Montreal
1939	AAM Summer
	Canadian Group of Painters, AGT, (AAM 1940)
	CNE
	Founding member of Contemporary Art Society
	Exhibition by the Canadian Group of Painters, New York World's Fair
	Golden Gate International Exposition of Contemporary Art, Department of Fine Arts, San Francisco
1940	Four-woman show, AGT
	Canadian Group of Painters
	Canadian National Committee on Refugees, NGC
	Contemporary Arts Society, AAM
	Montreal Women Artists, Women's Art Association
1940–46	CAS
1941	AAM Spring
	Canadian Group of Painters
1942	*Contemporary Painting in Canada*, Addison Gallery, Andover, MA
	Contemporary Arts Society, NGC
	Canadian Group of Painters, AGT, AAM, NGC
1943	*Canadian Group of Painters*

1944 *The H.S. Southam Collection*, NGC
Canadian Group of Painters, NGC, AGT, AAM
Contemporary Arts Society, AGT
Canadian Group of Painters/Contemporary Arts Society, AGT
Oil Paintings, Four-woman show, AAM
Canadian Art 1760–1943, Yale University Art Gallery, New Haven, CT
Pintura Canadese Contemporanea, Museu Nacional de Belas Artes, Rio de Janiero, Brazil

1945 Three-woman show, Willistead Art Gallery, Windsor, Ontario
The Development of Painting in Canada 1665–1945, AAM, AGT
Canadian Group of Painters, AGT (AAM 1946)

1946 *Exposition UNESCO*, Musee d'Art Moderne, Paris
Canadian Group of Painters
Contemporary Arts Society, AAM

1947 *Canadian Women Artists*, Riverside Museum, NYC , NGC

1948 *Memorial Exhibition Prudence Heward, 1896–1947*, NGC & circulating

1949 *Forty Years of Canadian Painting*, Museum of Fine Arts, Boston, MA
Fifty Years of Painting in Canada, AGT
Canadian Women Painters, West End Gallery, Montreal

1950 *Canadian Painting*, National Gallery of Art, Washington, DC

1951 *The Festival of Britain Exhibition*, Women's International Art Club, London, England, Berlin

1952	Tampa Florida State Fair
1953	*Inaugural Exhibition*, AGH
1954	Shakespearian Festival, Stratford, ON *400th Anniversary Exhibition*, Sao Paulo, Brazil *Exhibition of Canadian Paintings*, Pakistan, India, Ceylon
1960	*A Tribute to Women*, CNE Toronto
1961	*The Face of Early Canada*, London Public Library and Art Museum, London, ON
1964	Solo, Continental Galleries, Montreal
1966	*The Beaver Hall Hill Group*, NGC & circulating
1967	*Three Cities Collect*, London Art Gallery and Museum, London, ON
1968	*Exhibition of Canadian Paintings, 1850–1950*, NGC
1970	*Approaches to Figure Painting*, London Public Library and Art Museum, London, ON
1975	*Canadian Painting in the Thirties*, NGC *From Women's Eyes: Women Painters in Canada*, AEAC, Kingston, ON
1977	*Art Deco Tendencies*, Art Gallery of York University, Toronto
1978	*The Image of Man in Canadian Painting: 1878–1978*, University of Western Ontario, London, ON

1979 *Prudence Heward and Friends*, AGW

1980 *Contemporary Art Society, Montreal 1934–1948*, Edmonton Art Gallery, Edmonton, AB
 Prudence Heward Retrospective Exhibition, Walter Klinkhoff Gallery, Montreal

1982 *Women Painters of the Beaver Hall Group*, Sir George Williams Art Galleries, Montreal

1983 *Visions and Victories: 10 Canadian Women Artists*, London Regional Art Gallery, London, ON

1986 *Expressions of Will: The Art of Prudence Heward*, AEAC & circulating

1991 *Beaver Hall Hill Group*, Kaspar Art Gallery, Toronto

1997 *Montreal Women Painters on the Threshold of Modernity*, MMFA

MABEL LOCKERBY (1882–1976)

c. 1902 Begins studies at AAM

1903 AAM Scholarship Antique Class

1914–20 AAM Spring

1915 RCA Annual

1920 RCA
 Founder of Beaver Hall Group

1921–22	Beaver Hall Hill Annual Ex RCA
1922–26	AAM Spring
1922–29	RCA
1924–25	*British Empire Exhibition*, Wembley, England
1925	*Contemporary Canadian Artists*, Chowne Art Dealer, Montreal
1926	AGT *Special Exhibition of Canadian Art*, NGC NGC
1927	*Exposition d'art canadien*, Musée du Jeu de Paume, Paris
1928	*Exhibition of Paintings by the Group of Seven*, AGT
1928–29	*Annual Exhibition of Canadian Art*, NGC AAM Spring
1929	CNE
1930	*An Exhibition of Paintings by Contemporary Canadian Artists*, Corcoran Gallery, Washington, DC OSA Lyceum Women's Art Association, Toronto *Paintings by a Group of Contemporary Montreal Artists*, AAM

1931	Buenos Aires British Empire Trade Ex
1932	*Annual Exhibition of Canadian Art*, NGC
1932–33	AAM Spring
1933–34	*Exhibition of Paintings by Canadian Group of Painters*, AGT (AAM 1934)
1934	*Canadian Paintings, The Collection of the Hon. Vincent and Mrs. Massey*, AGT
1935–36	AAM Spring
1936	*Exhibition of Contemporary Canadian Paintings* (Carnegie Corporation), NYC, NGC & circulating
1936–37	*Canadian Group of Painters*, AGT, NGC (AAM 1938)
1937	*Exhibition of Paintings, Drawings and Sculpture by Artists of the British Empire Overseas* (Coronation Exhibition), Royal Institute Galleries, London, England Group Show of Modernists, Arts Club, Montreal
1938	*A Century of Canadian Art*, The Tate Gallery, London, England
1938–39	AAM Spring
1939	Elected member of Canadian Group of Painters *Exhibition by the Canadian Group of Painters*, New York World's Fair
c. 1940	Elected member of Contemporary Art Society *Canadian National Committee on Refugees*, NGC

	Contemporary Art Society, AAM
1941	Four-woman show, AGT
1942	*Canadian Group of Painters*, AGT, AAM, NGC AAM Spring
1944	*Canadian Group of Painters*, AGT, AAM *Canadian Art 1760–1943*, Yale University Art Gallery, New Haven, CT *Pintura Canadense Contemporanea*, Museu Nacional de Belas Artes, Rio de Janeiro Eaton's Galleries, Toronto
1946	Jury II Prize for *Old Towers* at AAM Spring Contemporary Art Society, AAM
1946–48	AAM Spring
1947	*Canadian Women Artists*, Riverside Museum, NY, NGC & circulating
1949	*Canadian Group of Painters*, AGT, MMFA & circulating *Canadian Women Painters*, West End Gallery, Montreal
1950	*Six Montreal Women Painters*, MMFA, Gallery XII *Canadian Group of Painters*, AGO (MMFA, 1951)
1951	AAM Spring Women's International Art Club, London, England
1952	Three-woman exhibition, MMFA, Gallery XII

1954	AAM Spring Sao Paulo 400th Anniversary Ex
1955–56	*Canadian Group of Painters*, AGO, MMFA
1956	AAM Spring
1958	*Canadian Group of Painters*, AGO, VAG
1960–61	*Canadian Group of Painters*, MMFA
1962	*Canadian Group of Painters*, AGO (NGC 1963)
1965	*Canadian Group of Painters*, Art Gallery of Greater Victoria, AEAC
1966	*The Beaver Hall Hill Group*, NGC & circulating
1967	MMFA
1982	*Women Painters of the Beaver Hall Group*, Sir George Williams Art Galleries, Montreal
1989	*Mabel Lockerby Retrospective Exhibition*, Walter Klinkhoff Gallery, Montreal
1991	*Beaver Hall Hill Group*, Kaspar Gallery, Toronto
1997	*Montreal Women Painters on the Threshold of Modernity*, MMFA

HENRIETTA MABEL MAY (1877–1971)

1910	AAM Spring

	AAM Scholarship in Life Class
	RCA Annual
1911	AAM Scholarship in Life Class
1914–15	Jessie Dow Prize for watercolour at AAM Spring
	Canadian Artists' Patriotic Fund Exhibition, RCA Public Library & circulating
1915	Women's Art Society Prize
	Elected to ARCA
1918	Jessie Dow Prize for oil painting at AAM Spring
1919	*Canadian War Memorial Exhibition*, AGT
1920	Founding member of Beaver Hall Group
1921–22	Annual Beaver Hall Group Exhibition
1923	NGC
1924	*Pictures Exhibited by the Montreal Group of Artists*, Hart House, Toronto
1924–25	*British Empire Exhibition*, Wembley, England
1925	*Contemporary Canadian Artists*, Chowne Art Dealer, Montreal
1926	*Special Exhibition of Canadian Art*, NGC
1927–33	*Annual Exhibition of Canadian Art*, NGC

1927 *Exposition d'art canadien*, Musée du Jeu de Paume, Paris

1928 *Exhibition of Paintings by the Group of Seven*, AGT

1930 *An Exhibition of Paintings by Contemporary Canadian Artists*, Corcoran Gallery of Art, Washington, DC
 Paintings by a Group of Contemporary Montreal Artists, AAM

1930–31 *Exhibition of the Group of Seven*, AGT

1933 Founding member of Canadian Group of Painters
 Exhibition of Paintings by Canadian Women Artists, Eaton's Fine Art Gallery, Montreal
 Paintings by the Canadian Group of Painters, Heinz Art Salon, Atlantic Cit
 Exhibition of Paintings by Canadian Group of Painters, AGT (AAM 1934)

1934 *Canadian Paintings, The Collection of the Hon. Vincent and Mrs. Massey*, AGT

1936 Exhibition of Contemporary Canadian Paintings, Carnegie Corporation, NGC & circulating
 Canadian Group of Painters, AGT and NGC

1937 *Exhibition of Paintings, Drawings and Sculpture of Artists of the British Empire Overseas* (Coronation Exhibition), Royal Institute Galleries, London, England
 Canadian Group of Painters, AGT (AAM 1938)

1938 *A Century of Canadian Art*, The Tate Gallery, London, England

1939 Solo, *Exhibition of Paintings by H. Mabel May*, James Wilson Art Galleries, Ottawa
 Exhibition by the Royal Canadian Academy of Arts, New York World's Fair
 Exhibition by the Canadian Group of Painters, New York World's Fair

1940	*Canadian National Committee on Refugees, Exhibition and Auction of Paintings*, NGC
1942	*Canadian Group of Painters*, AGT, AAM, NGC
1944	*Pintura Canadense Contemporanea*, Museu Nacional de Belas Artes, Rio de Janeiro, Brazil
1945	*The Development of Painting in Canada 1665–1945*, AAM, AGT
1947	*Canadian Women Artists*, Riverside Museum, New York, NGC & circulating *Canadian Group of Painters*, AGT (AAM 1948)
1949	*Canadian Group of Painters*, AGT, MMFA & circulating *Fifty Years of Painting in Canada*, AGT
1950	Solo, *Special Sale of Paintings by H. Mabel May, ARCA*, Dominion Gallery, Montreal
1951	Solo, Roberts Gallery, Toronto
1952	Solo Vancouver Art Gallery
1965	*Canadian Group of Painters*, AGV, AEAC
1966	*The Beaver Hall Hill Group*, NGC & circulating
1971	Solo, *Mabel May, ARCA*, Gallery of the Golden Gate, Vancouver
1975	*From Women's Eyes: Women Painters in Canada*, AEAC
1982	*Women Painters of the Beaver Hall Group*, Sir George Williams Art Galleries, Montreal

1991	*Beaver Hall Hill Group*, Kaspar Gallery, Toronto
1997	*Montreal Women Painters on the Threshold of Modernity*, MMFA

KATHLEEN MORRIS (1893–1986)

c. 1906	Begins studies at AAM
1914–1947	AAM Spring
1916	RCA, Montreal
1918	RCA, Montreal
1920	RCA, Montreal
1921	RCA, Toronto
1922	RCA, Montreal
1923	*3rd Annual Spring Exhibition of Ottawa Artists*, Chateau Laurier, Ottawa RCA, Toronto, Montreal
1924–25	CNE, Toronto *British Empire Exhibition*, Wembley, England *4th Annual Exhibition of Art Association of Ottawa*, Chateau Laurier, Ottawa *Four artists*, Art Association of Ottawa RCA, NGC, Ottawa
1925	*5th Annual Spring Exhibition by Ottawa Artists*, Chateau Laurier, Ottawa

Contemporary Canadian Artists, Chowne Art Dealer, Montreal
RCA, Montreal
CNE, Toronto
First Pan-American Exhibition of Oil Paintings, Los Angeles Museum
Works by Contemporary Canadian Artists, 40 McGill College Avenue, Montreal

1925–35 Ontario Society of Artists, AGT

1926 *Special Exhibition of Canadian Art*, NGC
 6th Annual Exhibition of Art Association of Ottawa, Wilson Gallery, Ottawa
 The Exhibition of the Group of Seven and Painting, Sculpture and Wood Carving
 of French Canada, AGT
 Exhibition of Canadian Paintings, Park Branch Art Gallery, Manchester, England
 RCA, Toronto
 CNE, Toronto

1927–8 *Annual Exhibition of Canadian Art*, NGC

1927 *Exposition d'art canadien*, Musée du Jeu de Paume, Paris
 7th Annual Exhibition of Art Association of Ottawa, Wilson Gallery, Ottawa
 Eaton's Gallery, Montreal
 Canadian Paintings, Hart House, Toronto
 RCA, Montreal

1928 *Annual Exhibition of Art Association of Ottawa*, Wilson Gallery, Ottawa
 3rd Exhibition of Canadian Art, NGC
 CNE, Toronto
 RCA, Toronto

1929–33 *Annual Exhibition of Canadian Art*, NGC

CNE, Toronto
RCA, Montreal
Ottawa Art Association, Ottawa
Elected Associate of the RCA

1930 McGill University, Montreal
 Paintings by a Group of Contemporary Canadian Artists, AAM
 An Exhibition of Paintings by Contemporary Canadian Artists, Corcoran Gallery,
 Washington & circulating
 First Exhibition of Canadian Arts, Manoir Richelieu, Murray Bay, Quebec
 RCA, Toronto

1931 RCA, Montreal
 Painters of Canada Series, W.E. Coutts Co, Montreal
 British Empire Trade Exhibition, Buenos Aires

1932 NGC
 RCA, Toronto

1933 *8th Annual Exhibition of Canadian Art*, NGC
 Exhibition of Paintings by Canadian Women Artists, Eaton's Gallery, Montreal
 CNE, Toronto
 RCA, Montreal
 Exhibition of Paintings by Canadian Group of Painters, AGT (AAM 1934)

1934 *Canadian Group of Painters*
 Eight Women Artists, Eaton's Gallery, Montreal
 Produced in Canada Exhibition, Sun Life, Montreal
 RCA, AGT
 RCA, NGC & circulating

Canadian Paintings, The Collection of the Hon. Vincent and Mrs. Massey, AGT

1935 CNE, Toronto
 RCA, Montreal

1936 *Canadian Group of Painters*, AGT, NGC
 RCA, AGT
 RCA, NGC & circulating
 Exhibition of Contemporary Canadian Paintings, Carnegie Corporation, NGC

1937 *Exhibition of Paintings, Drawings and Sculpture by Artists of the British Empire
 Overseas* (Coronation Exhibition), Royal Institute Galleries, London,
 England
 CNE, Toronto
 The Sixty-Third Annual Exhibition, Walker Art Gallery, Liverpool, England
 RCA, Montreal
 Canadian Group of Painters, AGT (AAM 1938)

1938 *Canadian Painters*, Eaton's Montreal
 A Century of Canadian Art, The Tate Gallery, London, England
 RCA, AGT
 Sale Aid to Spanish Democracy, 2037 Peel Street, Montreal
 RCA, NGC & circulating

1939 Solo at AAM
 Exhibition by the Royal Canadian Academy of Arts, New York World's Fair
 RCA, Montreal
 Canadian Group of Painters, AGT (AAM 1940)

1940 Elected member of Canadian Group of Painters

Canadian National Committee of Refugees, Exhibition and Auction of Canadian Paintings, NGC
RCA, AGT
Art of Our Day in Canada, CAS, AAM

1941 Four-woman show, AGT
 RCA, Montreal
 RCA, NGC & circulating

1942 RCA, AGT
 RCA, NGC & circulating
 Canadian Group of Painters, AGT, AAM, NGC

1943 RCA, Montreal
 RCA, NGC & circulating

1944 *Canadian Group of Painters*, AGT, AAM
 Pintura Canadense Contemporanea, Museo Nacional de Belas Artes, Rio de Janeiro

1945 Solo at Harris Memorial Gallery, Charlottetown, PEI
 Canadian Group of Painters, AGT (AAM 1946)

1946 RCA, AGT

1947 *Canadian Women Artists*, Riverside Museum, New York, NGC & circulating
 Canadian Group of Painters, AGT (AAM 1948)

1948 *Exhibition of Contemporary Canadian Painting*, Canadian Club of New York, NYC
 CNE
 First Annual Winter Exhibition, AGH

1949	*Canadian Group of Painters*, AGT, MMFA & circulating
	RCA, Montreal
	2nd Annual Winter Exhibition, AGH
1950	*Six Montreal Women Painters*, MMFA, Gallery XII
	Canadian Group of Painters, AGO (MMFA 1951)
	Contemporary Canadian Arts, RCA
	RCA, NGC & circulating
1951	*Canadian Group of Painters*
	RCA, AGT
	RCA with OSA
	Columbo Plan Exhibition, Ceylon
	Women's International Art Club, London, England
	CNE, Toronto
	4th Annual Winter Exhibition, AGH
1952	*Canadian Group of Painters*, AGT, MMFA
	RCA, Montreal
1953	RCA, NGC & circulating
	Spring Exhibition, MMFA
1954	*New Delhi International*
	6th Annual Winter Exhibition, AGH
1956	*Inaugural Exhibition of Paintings*, Cowansville Art Centre, Quebec
	Solo, Montreal Arts Club
1957	RCA, AGT, Halifax Memorial Library

Spring Exhibition, MMFA
Cowansville Art Association
8th Annual Winter Exhibition, AGH

1958 *Canadian Group of Painters*, AGO, VAG
9th Annual Winter Exhibition, AGH
RCA, MMFA, VAG

1962 Two-artist show, The Arts Club, Montreal
Maisonneuve Recreation Centre, Montreal
Canadian Group of Painters, AGO, NGC

1963 *14th Annual Winter Exhibition*, AGH
Canadian Group of Painters, MMFA (Calgary, 1964)

1964 *15th Annual Winter Exhibition*, AGH

1965 *Canadian Group of Painters*, Art Gallery Greater Victoria, AEAC

1966 *The Beaver Hall Hill Group*, NGC & circulating

1974 MMFA
From Macamic to Montreal, Man and His World

1975 *From Women's Eyes: Women Painters in Canada*, AEAC

1976 *Kathleen Morris, ARCA*, Walter Klinkhoff Gallery, Montreal
Trends and Influences in Canada, Glenbow-Alberta Institute, Calgary

1977 *Winters of Yesteryear*, Galerie A, Montreal

1979	*Prudence Heward and Friends*, AGW
1980	Canada Post 35-cent stamp
1982	*Women Painters of the Beaver Hall Group*, Sir George Williams University, Montreal
1983	*Kathleen Moir Morris*, AEAC
1991	*Beaver Hall Hill Group*, Kaspar Gallery, Toronto
1997	*Montreal Women Painters on the Threshold of Modernity*, MMFA
2003	*Kathleen Morris Retrospective*, Galerie Walter Klinkhoff, Montreal

LILIAS TORRANCE NEWTON (1896–1980)

1908	Enters AAM
1910	Scholarship AAM Junior Elementary Class
1914	Scholarship AAM Life Class
1916	RCA Annual
1918	RCA Annual
1920	Founding member of Beaver Hall Group
1920–22	AAM Spring

1920–24	RCA Annual
1921–22	Beaver Hall Group Annual
1923	Studies in Paris with Alexandre Jacovleff Première Mention d'Honneur for portrait of Denise Lamontagne at Annual Paris Salon Elected Associate of ARCA
1923–24	*An Exhibition of Modern Canadian Paintings*, Group of Seven U.S. tour
1924	*Pictures Exhibited by the Montreal Group of Artists*, Hart House, Toronto
1924–25	*British Empire Exhibition*, Wembley, England
1925	AAM Spring Panama Pacific Exposition, Los Angeles *Contemporary Canadian Artists*, Chowne Art Dealer, Montreal
1926	*Special Exhibition of Canadian Art*, NGC
1926–33	*Annual Exhibition of Canadian Art*, NGC
1927	*Exposition d'art canadien*, Musee du Jeu de Paume, Paris RCA Annual
1929–30	RCA Annual
1930	Solo, Hart House, Toronto *An Exhibition of Paintings by Contemporary Canadian Artists*, Corcoran Gallery of Art, Washington, DC

Paintings by a Group of Contemporary Montreal Artists, AAM

1930–31 *Exhibition of the Group of Seven*, AGT

1931 Three-artist show, Watson Art Galleries, Montreal
First Baltimore Pan American Exhibition of Contemporary Painting, Baltimore
 Museum of Art, Baltimore, MD
British Empire Exhibition, Buenos Aires

1931–33 NGC

1932 Solo, Arts Club, Montreal

1932–35 RCA Annual

1933 Founding member of Canadian Group of Painters
Paintings by the Canadian Group of Painters, Heinz Art Salon, Atlantic City, NJ
Exhibition of Paintings by the Canadian Group of Painters, AGT (AAM 1934)

1934 *Canadian Paintings, The Collection of the Hon. Vincent and Mrs. Massey*, AGT
Canadian Group of Painters

1934–35 AAM Spring

1936 *Exhibition of Contemporary Canadian Paintings*, Carnegie Corporation, NY, NGC
 & circulating

1937 Elected member of RCA
RCA Annual
AAM Spring

Paintings, Drawings and Sculpture by Artists of the British Empire Overseas (Coronation Exhibition), Royal Institute Galleries, London, England
Canadian Group of Painters, AGT (AAM 1938)

1938 *A Century of Canadian Art*, The Tate Gallery, London, England
Sale Aid to Spanish Democracy, 2037 Peel Street, Montreal

1939 *Exhibition by the Royal Canadian Academy of Arts*, New York World's Fair
Exhibition by the Canadian Group of Painters, New York World's Fair
Solo, AAM
AAM Spring

1939–42 RCA Annual

1940 Four-artist show, AGT
Canadian National Committee on Refugees, NGC

1940–43 AAM Spring

1942 *Canadian Group of Painters*, AGT, AAM, NGC

1944 RCA Annual
Four-woman show, AAM
Canadian Art 1760-1943, Yale University Art Gallery, New Haven, CT

1944–45 *Canadian Group of Painters*, AGT (AAM 1946)

1945 Solo, Photographic Stores, Ottawa
The Development of Painting in Canada 1665–1945, AGT, AAM

1946–47	RCA Annual
1947	*Canadian Group of Painters*, AGT
	Exhibition of Paintings by Canadian Women Artists, Riverside Museum, New York, NGC
1947–53	AAM Spring
1948	*Canadian Group of Painters*
1949	*Forty Years of Painting, from Tom Thomson and the Group of Seven to the Present Day*, Museum of Fine Arts, Boston, MA
	Canadian Group of Painters, AGT, MMFA & circulating
	Canadian Women Painters, West End Gallery, Montreal
1950	*Canadian Painting*, National Gallery, Washington, DC
	Canadian Group of Painters, AGO
1950–54	RCA Annual
1951	MMFA
	Canadian Group of Painters
1956–58	RCA Annual
1958	Solo, Victoria College, Toronto
1960	*A Tribute to Women*, Canadian National Exhibition, Toronto
	Canadian Portrait Exhibition, Hart House, Toronto

1966 *The Beaver Hall Hill Group*, NGC & circulating

1967 *Three Hundred Years of Canadian Art*, NGC

1972 LL.D. University of Toronto

1975 *Canadian Painting in the Thirties*, NGC
 From Women's Eyes, AEAC, Kingston, ON

1979–80 *Figures and Portraits of the 1930s and 1940s*, AGO

1980 *Selected Figures and Portraits of the Hart House Permanent Collection*, Hart House, Toronto

1981 *Lilias Torrance Newton 1896–1980*, AEAC, Kingston, ON

1982 *Women Painters of the Beaver Hall Group*, Sir George Williams Art Galleries, Montreal

1983 *Visions and Victories*, London Regional Art Gallery, London, ON

1991 *Beaver Hall Hill Group*, Kaspar Gallery, Toronto

1994–95 *Au Féminin: Collection du Musée, 1920–1950*, Musée du Québec

1995 *Lilias Torrance Newton Retrospective*, La Galerie Walter Klinkhoff, Montreal

1997 *Montreal Painters on the Threshold of Modernity*, MMFA, Montreal

SARAH ROBERTSON (1891–1948)

1910	Scholarship AAM in Senior Elementary Class
1912–16	AAM Spring
1919	Women's Art Society Scholarship
1919–29	AAM Spring
1920	Kenneth R. Macpherson Prize
1920–23	RCA Annual
1922	Beaver Hall Group Kenneth R. Macpherson Prize
1923	Women's Art Society Scholarship
1924	*Pictures Exhibited by the Montreal Group of Artists*, Hart House, Toronto
1924–25	*British Empire Exhibition*, Wembley, England
1925	*Contemporary Canadian Artists*, Chowne Art Dealer, Montreal
1925–27	RCA
1926	*French Canadian Exhibition*, AGT
1926–30	*Special Exhibition of Canadian Art*, NGC

1927	*Exposition d'art canadien*, Musee du Jeu de Paume, Paris
1928	*Exhibition of Paintings by the Group of Seven*, AGT
	Exhibition of Paintings by Canadian Artists, Buffalo Fine Arts Academy, Buffalo, NY
1930	*An Exhibition of Paintings by Contemporary Canadian Artists*, Corcoran Gallery of Art, Washington, DC
	Paintings by a Group of Contemporary Montreal Artists, AAM
1930–31	*Exhibition of the Group of Seven*, AGT
1931	*First Baltimore Pan American Exhibition of Contemporary Painting*, Baltimore Museum of Art, MD
	British Empire Trade Fair, Buenos Aires
1932	AAM Spring
	Exhibition of Paintings by Contemporary Canadian Artists, Roerich Museum, NYC
1932–33	Annual Exhibition of Canadian Art, NGC
1933	Founding member of Canadian Group of Painters
	Exhibition of Paintings by Canadian Women Artists, Eaton's Fine Art Gallery, Montreal
	Paintings by the Canadian Group of Painters, Heinz Art Salon, Atlantic City, NJ
	Exhibition of Paintings by Canadian Group of Painters, AGT (AAM 1934)
1934	*Canadian Group of Painters*, AGT, NGC
	RCA
	Three-woman show, Hart House, Toronto, W. Scott & Sons, Montreal
	Canadian Paintings, The Collection of the Hon. and Mrs. Vincent Massey, AGT

1935–42	AAM Spring
1936	*Canadian Group of Painters*, AGT, NGC *Exhibition of Contemporary Canadian Paintings*, Carnegie Corporation of New York, NYC
1937	Modernists Arts Club, Montreal *Exhibition of the International Society of Women Painters and Sculptors*, Women's Art Association of Canada, Toronto *Canadian Group of Painters*, AGT (AAM 1938) *Exhibition of Paintings, Drawings and Sculpture by Artists of the British Empire Overseas* (Coronation Exhibition), Royal Institute Galleries, London, England
1938	*A Century of Canadian Art*, Tate Gallery, London, England
1939	*Golden Gate International Exposition of Contemporary Art*, Department of Fine Arts, San Francisco *Exhibition by the Canadian Group of Painters*, N.Y. World's Fair *Canadian Group of Painters*, AGT (AAM 1940)
1940	Four-woman exhibition, AGT *Canadian National Committee on Refugees Exhibition and Auction*, NGC *Contemporary Arts Society*, AAM
1942	*Canadian Group of Painters*, AGT, AAM, NGC
1944	*Canadian Art 1760-1943*, Yale University Art Gallery, New Haven, CT *Pintura Canadense Contemporanea*, Museu Nacional de Belas Artes, Rio de Janeiro

1945 *The Development of Painting in Canada 1665–1945*, AGT, AAM
 AAM Spring

1947 *Canadian Women Artists*, Riverside Museum, New York, NGC
 Canadian Group of Painters, AGT (AAM 1948)

1949 *Canadian Women Painters*, West End Gallery, Montreal

1951 *Sarah Robertson Memorial Exhibition*, NGC

1966 *The Beaver Hall Hill Group*, NGC & circulating

1975 *Canadian Painting in the Thirties*, NGC
 From Women's Eyes: Women Painters in Canada, AEAC

1979 *Prudence Heward and Friends*, AGW

1982 *Modernism in Quebec Art, 1916–46*, NGC
 Women Painters of the Beaver Hall Group, Sir George Williams Art Galleries, Montreal

1983 *Visions and Victories: 10 Canadian Women Artists*, London Regional Art Gallery,
 London, ON

1991 *Sarah Robertson Retrospective Exhibition*, La Galerie Walter Klinkhoff, Montreal
 Beaver Hall Hill Group, Kaspar Gallery, Toronto

1997 *Montreal Women Painters on the Threshold of Modernity*, MMFA

ANNE SAVAGE (1896–1971)

1915	AAM Scholarship Antique Class
1917–26	AAM Spring
1918	RCA
1919	Kenneth R. MacPherson Prize, AAM
1919	Studies at Minneapolis School of Design
1920	Founding member of Beaver Hall Group
1920–23	RCA
1920–21	Beaver Hall Group
1924	*Pictures Exhibited by the Montreal Group of Artists*, Hart House, Toronto
1924–25	*British Empire Exhibition*, Wembley, England
1925	RCA
1926	*Exhibition of the Group of Seven*, AGT
1926–33	*Exhibition of Canadian Art*, NGC
1927	*Exposition d'Art Canadien*, Musee du Jeu de Paume, Paris

1927–29 RCA

1928 *Contemporary Canadian Paintings*, AAM
 The Downfall of Temlaham, painting in publication
 Canadian West Coast Art, NGC

1928–29 AAM Spring

1929 CNE
 AAM Spring

1929–30 *Exhibition of work by Quebec Artists*, Eaton's Montreal

1930 *An Exhibition of Paintings by Contemporary Canadian Artists*, Corcoran Gallery,
 Washington, DC & circulating
 Paintings by a Group of Contemporary Montreal Artists, AAM

1931 AAM Spring
 RCA
 CNE
 First Baltimore Pan American Exhibition of Contemporary Painting, Baltimore
 Museum of Art, MD
 Exhibition of the Group of Seven, AGT

1932 *Montreal Artists*, W. Scott's Gallery, Montreal
 Exhibition of Paintings by Contemporary Canadian Artists, Roerich Museum,
 New York

1933 Founding member of Canadian Group of Painters
 AAM Spring

Paintings by the Canadian Group of Painters, Heinz Art Salon, Atlantic City
Exhibition of Paintings by the Canadian Group of Painters, AGT (AAM 1934)

1933–34 *Canadian Group of Painters*, AGT

1933–42 AAM Spring

1934 *Canadian Paintings, The Collection of the Hon. Vincent and Mrs. Massey*, AGT
Exhibition of Paintings by the Canadian Group of Painters, AAM

1936 *Exhibition of Contemporary Canadian Paintings* (Carnegie Corporation), NYC,
 NGC & circulating
Empire Exhibition of Contemporary Canadian Painting, Johannesburg, South Africa

1936–37 *Canadian Group of Painters*, AGT (AAM 1938)

1937 *Exhibition of Paintings, Drawings and Sculpture by Artists of the British Empire
 Overseas* (Coronation Exhibition), Royal Institute Galleries, London, England
Sixty-third Autumn Exhibition, Walker Art Gallery, Liverpool, England

1938 *A Century of Canadian Art*, The Tate Gallery, London, England
Sale Aid to Spanish Democracy, 2037 Peel Street, Montreal

1939 *Canadian Group of Painters*, AGT
 CNE
Golden Gate International Exposition of Contemporary Art, Department of Fine
 Arts, San Francisco
Exhibition by the Canadian Group of Painters, New York World's Fair
 AAM Summer

1940	Four-woman show, AGT
	Canadian Group of Painters, AAM
	Canadian National Committee on Refugees, NGC

| 1942 | *Canadian Group of Painters*, AGT, AAM, NGC |

1944	AAM Spring
	Four-woman show, AAM
	Canadian Art, 1760-1943, Yale University Art Gallery, New Haven, CT

| 1944–50 | *Canadian Group of Painters*, AGT (AAM next year) |

| 1945 | *The Development of Painting in Canada 1665–1945*, AAM, AGT |
| | Three-woman show, Willistead Art Gallery, Windsor, ON |

| 1946–49 | AAM Spring |

| 1947 | *Canadian Women Artists*, Riverside Museum, New York, NGC |
| | *Exhibition of Paintings by Canadian Women Artists*, NGC |

1949	Elected president of Canadian Group of Painters, Montreal
	Canadian Group of Painters, MMFA & circulating
	Canadian Women Painters, West End Gallery, Montreal

| 1950 | Six-woman show, MMFA |

| 1952 | *Canadian Group of Painters* |

| 1954–60 | *Canadian Group of Painters*, AGO |

1956	Solo, YWCA, Montreal
	Inaugural Exhibition of Paintings, Cowansville Art Centre, Quebec
	MMFA Spring
1958	*Canadian Group of Painters*, VAG, AGO
1960	President of the Canadian Group of Painters
	Canadian Group of Painters, MMFA
1959–61	MMFA Spring
1963	*Canadian Group of Painters*, MMFA & Calgary
	Two-artist exhibition at Artlenders Gallery, Montreal
1964	*Canadian Group of Painters*, Calgary
	Women Painters of Quebec, MMFA
1965	*Canadian Group of Painters*, AGV, AEAC
	Canadian Group of Painters, MMFA
1966	*The Beaver Hall Hill Group*, NGC & circulating
	Canadian Group of Painters
1967	*Canadian Group of Painters*, MMFA
1969	*Anne Savage, a Retrospective*, Sir George Williams Art Galleries, Montreal
1974	*Annie D. Savage: Drawings and Watercolours*, Sir George Williams Art Galleries, Montreal

1975 *Canadian Painting in the Thirties*, NGC

1977 *The Laurentians, Painters in a Landscape*, AGO

1978 *Anne Savage*, Gallery A, Montreal

1979–81 Solo, MMFA circulating

1982 *Women Painters of the Beaver Hall Group*, Sir George Williams Art Galleries, Montreal

1991 *Beaver Hall Hill Group*, Kaspar Gallery, Toronto

1992 *Anne Savage: Retrospective Exhibition*, La Galerie Walter Klinkhoff, Montreal

1997 *Montreal Women Painters on the Threshold of Modernity*, MMFA

2002 *Anne Savage*, Leonard and Bina Ellen Art Gallery, Concordia University, Montreal

ETHEL SEATH (1879–1963)

c. 1898 Studies at Conseil des Arts and Manufactures

1905 AAM Spring

1906 RCA Annual

1925 *British Empire Exhibition*, Wembley, England

1927	*Exposition d'art canadien*, Musée du Jeu de Paume, Paris
1927–28	*Annual Exhibition of Canadian Art*, NGC
1930	*Paintings by a Group of Contemporary Montreal Artists*, AAM
1931–3	*Annual Exhibition of Canadian Art*, NGC
1933	*Exhibition of Paintings by Canadian Group of Painters*, AGT (AAM 1934)
1934	*Canadian Paintings, The Collection of the Hon. Vincent and Mrs. Massey*, AGT
1936	*Exhibition of Contemporary Canadian Paintings* (Carnegie Corporation), NGC
1936	*Canadian Group of Painters*, AGT, NGC
1937	*Exhibition of Paintings, Drawings and Sculpture by Artists of the British Empire* (Coronation Exhibition), Royal Institute Galleries, London, England *Canadian Group of Painters*, AGT (AAM 1938)
1938	*A Century of Canadian Art*, Tate Gallery, London, England
1939	Elected to Canadian Group of Painters *Canadian Group of Painters*, AGT (AAM 1940) *Exhibition by the Group of Canadian Painters*, New York World's Fair
c. 1940	Elected to Contemporary Arts Society *Canadian National Committee on Refugees*, NGC *Contemporary Arts Society*, AAM

1940	Four-woman show, AGT
1942	*Canadian Group of Painters*, AGT, AAM, NGC
1944	*Oil Paintings by Prudence Heward, Lilias Torrance Newton, RCA, Anne Savage, and Ethel Seath*, AAM
1944–45	*Canadian Group of Painters*, AGT (AAM 1946) *Canadian Art 1760–1943*, Yale University Art Gallery, New Haven, CT *Pintura Canadense Contemporanea*, Museu Nacional de Belas Artes, Rio de Janeiro, Brazil
1945	Three-woman show, Willistead Art Gallery, Windsor, ON AAM
1946	AGT
1947	*Canadian Women Artists*, Riverside Museum, New York, NGC & circulating *Canadian Group of Painters*, AGT (AAM 1948)
1949	*Canadian Group of Painters*, AGT, MMFA & circulating *Canadian Women Painters*, West End Gallery, Montreal
1950	*Six Montreal Women Painters*, MMFA, Gallery XII *Canadian Group of Painters*, AGO (MMFA 1951)
1952	Three-woman exhibition, MMFA, Gallery XII
1954	*Canadian Group of Painters*, AGO, NGC & circulating

1955 *Canadian Group of Painters*, AGO, MMFA
 Art from The Study, Montreal

1956 *Inaugural Exhibition of Paintings*, Cowansville Art Centre, Quebec
 Canadian Group of Painters, AGO (VAG 1957)

1957 Solo, YWCA, Montreal
 Canadian Group of Painters, MMFA
1958 *Canadian Group of Painters*, AGO, VAG

1960 *Canadian Group of Painters*, MMFA

1962 Two-artist exhibition, MMFA

1966 *The Beaver Hall Hill Group*, NGC & circulating

1982 *Women Painters of the Beaver Hall Group*, Sir George Williams Art Galleries,
 Montreal

1987 *Ethel Seath Retrospective Exhibition*, Walter Klinkhoff Gallery, Montreal

1991 *Beaver Hall Hill Group*, Kaspar Gallery, Toronto

1997 *Montreal Women Painters on the Threshold of Modernity*, MMFA

NOTES

Introduction

1 A.Y. Jackson, "Public Profession of Artistic Faith: Nineteen Painters Represented in 'Beaver Hall Group's' Exhibition," *The Gazette* (Montreal), 18 January 1921, 2.

2 Jackson, "Public Profession of Artistic Faith," 2.

3 Paul Duval, *Four Decades: The Canadian Group of Painters and Their Contemporaries, 1930–1970* (Toronto: Clark, Irwin & Co. Ltd., 1972), 41.

4 Arthur H. Calvin, "Anne Savage, Teacher" (master's thesis, Sir George Williams University, 1967), 13.

5 S. Morgan-Powell, "Art and the Post-Impressionists," *The Montreal Daily Star*, 29 March 1913, 22.

6 S. Morgan-Powell, "A Few Notable Canvases, but a Lower Average," *The Montreal Daily Star*, 23 November 1918, 2.

7 S. Morgan-Powell, "Spring Exhibition at Art Gallery is an Indifferent Show," *The Montreal Star*, 7 April 1926.

8 Esther Trépanier, *Montreal Women Painters on the Threshold of Modernity*, Catalogue (Montreal: Montreal Museum of Fine Arts, 1997).

9 Francois-Marc Gagnon, "Painting in Quebec in the Thirties," *Journal of Canadian Art History* 3, nos. 1 & 2 (1976): 10.

10 Donald W. Buchanan, "Naked Ladies," *The Canadian Forum* 15, no. 175 (1935).

Chapter 1: Nora Collyer

11 Barbara Meadowcroft, *Painting Friends The Beaver Hall Women Painters* (Montreal: Véhicule Press, 1999), 101.

12 Albert Laberge, "Une visite à l'exposition de peintures," *La Presse* (Montreal), 22 March 1922.

13 S. Morgan-Powell, "A Final Glance Around the Art Exhibition Here," *Montreal Daily Star*, 12 April 1922.

14 Robert Ayre, "Gentlemen and Ladies!" *The Montreal Star*, 25 April 1964.

Chapter 2: Emily Coonan

15 Meadowcroft, *Painting Friends*, 45.

16 St. G. B., "Art and Artists," *The Daily Herald* (Montreal), 9 April 1910, 9.

17 Karen Antaki, "Rediscovering Emily Coonan," *Emily Coonan (1885–1971)*, Catalogue (Montreal: Concordia Art Gallery, 1987), 23.

18 "Futurist Pictures Cause Stir at Spring Art Exhibit," *The Daily Herald* (Montreal), 26 March 1913.

19 Palette, "The Spring Exhibition at the Montreal Art Gallery," *The Saturday Mirror* (Montreal), 29 March 1913.

20 S. Morgan-Powell, "Spring Exhibition at Art Gallery Is Along Normal Lines," *The Montreal Star*, 21 March 1923, 6.

Chapter 3: Prudence Heward

21 Eliza M. Jones, *Dairying for a Profit; or, The Poor Man's Cow* (Montreal: John Lovell & Son, 1892).

22 Quoted in Janet Braide, *Prudence Heward (1896–1947)*, Catalogue (Montreal: Walter Klinkhoff Gallery, 1980), 16.

23 Frederick Housser, "Canadian Art Ready to Go," *Toronto Telegram*, 24 January 1930.

24 Heward Grafftey, *Portraits from a Life* (Montreal: Véhicule Press, 1996), 72.

25 Edwin H. Holgate, "Prudence Heward," *Canadian Art* 4, no. 4 (1947).

26 Grafftey, *Portraits from a Life*, 68.

27 Grafftey, *Portraits from a Life*, 78.

28 Paul Duval, "Prudence Heward Show," *Saturday Night* 62, no. 29 (1948), 19.

Chapter 4: Mabel Lockerby

29 Meadowcroft, *Painting Friends*, 86.

30 Albert Laberge, "Une visite à l'exposition de peintures," *La Presse* (Montreal), 22 March 1922.

31 A.H. Robson, *Canadian Landscape Painters* (Toronto: Ryerson, 1932), 176.

Chapter 5: Henrietta Mabel May

32 Karen Antaki, "H. Mabel May (1877–1971): The Montreal Years: 1909–1938" (thesis, Concordia University, 1992) 9. May's birth date is sometimes given as 1884, but family documents prove otherwise.

33 Anne Savage, *Henrietta Mabel May*, Anne Savage Archives, File 6, #2.21, (Montreal: Concordia University).

34 Esther Trépanier, *Montreal Women Painters on the Threshold of Modernity*, Catalogue (Montreal: Montreal Museum of Fine Arts, 1997).

35 Antaki, "H. Mabel May," 100.

36 E.W.H., "H. Mabel May, A.R.C.A., Exhibits Some Vigorous Landscapes in Show," *The Ottawa Citizen*, 27 January 1939.

37 *Toronto Star*, 18 February 1950.

38 Robert Ayre, "Art in Montreal — From Good to Indifferent," *Canadian Art* 8, no. 1 (1950): 34.

Chapter 6: Kathleen Morris

39 Frances K. Smith, *Kathleen Moir Morris* Catalogue (Kingston: Agnes Etherington Art Centre, 1983), 13.

40 W.G. Constable, "Artists of the Empire," *The Listener*, BBC, (London: 5 May 1937).

41 Dorothy Pfeiffer, "At the Arts Club," *The Gazette* (Montreal), 3 March 1962.

Chapter 7: Lilias Torrance Newton

42 Anon., "Canadian Women in the Public Eye: Lilias Torrance Newton," *Saturday Night* 41, no. 52 (1927): 35.

43 Dorothy Farr, *Lilias Torrance Newton: 1896–1980*, Catalogue (Kingston: Agnes Etherington Art Centre, 1981), 16.

44 Donald W. Buchanan, "Naked Ladies," *The Canadian Forum* 15, no. 175 (1935): 273.

45 Dorothea Fyfe, Letter to Lilias T. Newton, 16 March 1936, Newton Papers, (Ottawa: National Gallery of Canada).

46 Julian Armstrong, "Montreal Artist Ready to Paint Queen, Nervous at Thought of Entering Palace," *Montreal Gazette*, 16 February 1957.

Chapter 8: Sarah Robertson

47 Robertson, Montreal to Brown, Ottawa, 2 December, 1931, NGC, curatorial file for Robertson, *Joseph and Marie- Louise*, (acc.15545).

48 A.Y. Jackson, "Sarah Robertson, 1891–1948," *Canadian Art* 6, no. 3 (1949): 125.

49 Esther Trépanier, *Montreal Women Painters on the Threshold of Modernity*, Catalogue (Montreal: Montreal Museum of Fine Arts, 1997).

50 Joyce Millar, "The Beaver Hall Group Painting in Montreal 1920–1940," *Women's Art Journal* 13, no. 1 (1992): 6.

51 A.Y. Jackson, "Introduction," in *Sarah Robertson, 1891–1948: Memorial Exhibition: National Gallery of Canada, Ottawa, 1951*, Catalogue (Ottawa: National Gallery of Canada, 1951).

Chapter 9: Anne Savage

52 Anne McDougall, *Anne Savage: The Story of a Canadian Painter* (Montreal: Harvest House, 1977), 12.

53 Paul Duval, *Four Decades The Canadian Group of Painters and Their Contemporaries 1930–1970* (Toronto: Clark Irwin & Co Ltd., 1972), 42.

54 McDougall, *Anne Savage*, 161.

55 McDougall, *Anne Savage*, 201.

56 Barbara Meadowcroft, *Retrospective Exhibition September 12–26, 1992: Anne Savage (1896–1971)*, Catalogue (Montreal: La Galerie Walter Klinkhoff, 1992).

Chapter 10: Ethel Seath

57 Roger Little, "Introduction," in *Retrospective Exhibition Sept 14–26, 1987: Ethel Seath (1879–1963)*, Catalogue (Montreal: Walter Klinkhoff Gallery, 1987).

58 Robert Ayre, "Art Notes: Montreal Season Gains Impetus," *Montreal Star*, 20 October 1962, 8.

59 Little, "Introduction."

BIBLIOGRAPHY

Adamson, Jeremy, ed. *The Hart House Collection of Canadian Paintings*. Toronto: University of Toronto Press, 1969.

Andrus, Donald F.P., ed. *Annie D. Savage: Drawings and Watercolours*. Catalogue. Montreal: Sir George Williams Art Galleries, 1974.

Antaki, Karen, ed. *Emily Coonan (1885–1971)*. Catalogue. Montreal: Concordia University, 1987.

———. "H. Mabel May (1877–1971) The Montreal Years: 1909–1938." Thesis, Concordia University, 1992.

Avon, Susan. "The Beaver Hall Group and its Place in the Montreal Art Milieu and the Nationalist Network." Thesis, Concordia University, 1994.

Beavis, Lynn, ed. *Anne Savage*. Catalogue. Montreal: Leonard & Bina Ellen Art Gallery. Montreal: Concordia University, 2002.

Bernier, Robert. *Un Siècle de Peinture au Québec: Nature et Paysage*. Montreal: Les Editions de l' Homme, 1999.

Braide, Janet, ed. *Anne Savage: Her Expression of Beauty*. Montreal: Montreal Museum of Fine Arts, 1979.

———. *Prudence Heward (1896–1947): An Introduction to her Life and Work*. Catalogue. Montreal: Walter Klinkhoff Gallery, 1980.

Burnett, Davis, and Marilyn Schiff. *Contemporary Canadian Art*. Edmonton: Hurtig Publishers Ltd., 1983.

By Woman's Hand: A Tribute to Three Women Whose Lives and Works Were Almost Forgotten. Directed by Pepita Ferrari and Erna Buffie. National Film Board of Canada, 1995.

Chauvin, Jean. *Ateliers: etudes sur vingt-deux peintres et sculpteurs canadiens.* Montreal: Louis Carrier & Cie., 1928.

Constable, W.G. "Artists of the Empire". *The Listener*. BBC. London: 5 May, 1937.

Duval, Paul. *Canadian Impressionism.* Toronto: McLelland & Stewart Inc., 1990.

Farr, Dorothy, ed. *Lilias Torrance Newton 1896–1980.* Catalogue. Kingston: Agnes Etherington Art Centre, 1981.

Farr, Dorothy, and Luckyj Natalie, eds. *From Women's Eyes: Women Painters in Canada.* Kingston: Agnes Etherington Art Centre, 1975.

Fenton, Terry, and Wilkin, Karen. *Modern Painting in Canada: Major Movements in Twentieth Century Art.* Edmonton: Hurtig Publishers, 1978.

Grafftey, Heward. *Portraits from a Life.* Montreal: Véhicule Press, 1996.

Groves, Naomi Jackson, ed. *Works by A.Y. Jackson from the 1930s.* Catalogue. Ottawa: Carleton University Press, 1990.

Hayes, Jr., Bartlett H., and Marcel Parizeau, eds. *Aspects of Contemporary Painting in Canada, 1942. September 18–November 8, 1942.* Catalogue. Andover, Massachusetts: Addison Art Gallery of American Art, 1942.

Hill, Charles, ed. *Canadian Painting in the Thirties.* Catalogue. Ottawa: National Gallery of Canada, 1975.

———. *The Group of Seven: Art for a Nation.* Ottawa: National Gallery of Canada, 1995.

Kozinska, Dorota, ed. *Retrospective Exhibition: Kathleen Morris (1893–1986).* Catalogue. Montreal: Walter Klinkhoff Gallery, 2003.

Luckyj, Natalie, ed. *Expressions of Will: The Art of Prudence Heward.* Catalogue. Kingston: Agnes Etherington Art Centre, 1986.

———. *Visions and Victories: 10 Canadian Women Artists 1914–1945.* Catalogue. London: London Regional Art Gallery, 1983.

MacDonald, Colin S, ed. *A Dictionary of Canadian Artists.* 5th ed. Ottawa: Canadian Paperbacks Publishing, 1967.

McCullogh, Norah, ed. *The Beaver Hall Hill Group: Exhibition Organized and Circulated by The National Gallery of Canada*. Catalogue. Ottawa: National Gallery of Canada, 1966.

McCurry, H.O, ed. *Prudence Heward, 1896–1947: Memorial Exhibition: National Gallery of Canada, Ottawa 1948*. Catalogue. Ottawa: National Gallery of Canada, 1948.

———. *Sarah Robertson, 1891–1948 Memorial Exhibition: National Gallery of Canada, Ottawa, 1951*. Catalogue. Ottawa: National Gallery of Canada, 1951.

McDougall, Anne. *Anne Savage: The Story of a Canadian Painter*, Montreal: Harvest House, 1977.

Meadowcroft, Barbara. *Painting Friends: The Beaver Hall Women Painters*. Montreal: Véhicule Press, 1999.

Meadowcroft, Barbara, ed. *Retrospective Exhibition: Anne Savage (1896–1971)*. Catalogue. Montreal: La Galerie Walter Klinkhoff, 1992.

———. *Retrospective Exhibition: Ethel Seath (1879–1963)*. Catalogue. Montreal: Walter Klinkhoff Gallery, 1987.

———. *Retrospective Exhibition: Lilias Torrance Newton (1896–1980)*. Catalogue. Montreal: La Galerie Walter Klinkhoff, 1995.

———. *Retrospective Exhibition: Mabel Lockerby (1882–1976)*. Catalogue. Montreal: La Galerie Walter Klinkhoff, 1989.

———. *Retrospective Exhibition: Sarah Robertson (1891–1948)*. Catalogue. Montreal: La Galerie Walter Klinkhoff, 1991.

Millar, Joyce. "The Beaver Hall Group Painting in Montreal 1920–1940." *Women's Art Journal*. Vol. 13. No. 1 (Spring/Summer, 1992). Laverock, PA: 1992

Murray, Joan. *Pilgrims in the Wilderness: the Struggle of the Canadian Group of Painters 1933–1969*. Oshawa: Robert McLaughlin Gallery, 1993.

Oliver, Dean F. and Brandon, Laura. *Canvas of War: Painting the Canadian Experience 1914–1945*. Hull: Canadian Museum of Civilization Corporation, 2000.

Ostiguy, Jean-René, ed. *Modernism in Quebec Art, 1916–1946*. Catalogue. Ottawa: National Gallery of Canada, 1982.

The Other Side of the Picture. Dirs. MacInnes, Teresa and Kovanic, Gillian Darling. National Film Board of Canada, 1993.

Paikowsky, Sandra, ed. *Defining the Portrait, October 30–December 15, 2001.* Catalogue. Montreal: Leonard & Bina Ellen Art Gallery, Concordia University, 2001.

Robson, Albert H. *Canadian Landscape Painters.* Toronto: Ryerson, 1932.

Savage, Anne. *Henrietta Mabel May.* Anne Savage Archives. Montreal: Concordia University.

Sherman, Leah, ed. *Anne Savage.* Catalogue. Montreal: Concordia University, 2002.

Smith, Frances K.,ed. *Kathleen Moir Morris.* Catalogue. Kingston: Agnes Etherington Art Centre, 1983.

The Tate Gallery. *A Century of Canadian Art.* Catalogue. London, England: The Tate Gallery, 1938.

Tippett, Maria. *By a Lady: Celebrating Three Centuries of Canadian Art by Canadian Women.* Toronto: Viking, 1992.

Taylor, David G., ed. *The Female Perspective: Emily Carr to the Present, Selected Canadian Women Artists from the Permanent Collections of Gallery Lambton and Other Public Galleries.* Sarnia, Ontario: Gallery Lambton, 1998.

Trépanier, Esther. *Peinture et Modernité au Québec 1919–1939.* Montreal: Editions Nota Bene, 1998.

Trépanier, Esther, ed. *Montreal Women Painters on the Threshold of Modernity.* Catalogue. Montreal: Montreal Museum of Fine Arts, 1997.

INDEX OF ILLUSTRATIONS

EMILY COONAN (1885–1971)

3. *At the Theatre*, 1928 40
 Oil on canvas, 101.6 x 101.6 cm
 Purchase, Horsley and Annie Townsend Bequest
 Coll: The Montreal Museum of Fine Arts
 Photo: Brian Merrett, MMFA
 1964.1497

4. *Rollande*, 1929 41
 Oil on canvas, 139.9 x 101.7 cm
 National Gallery of Canada
 Purchased 1930

5. *Sisters of Rural Quebec*, 1930 42
 Oil on canvas, 157.4 x 106.6 cm
 Collection of the Art Gallery of Windsor
 Gift of the Women's Committee, 1962

6. *Girl Under a Tree*, 1931 44
 Oil on canvas, 122.5 x 193.7 cm
 Art Gallery of Hamilton
 Gift of the artist's family, 1961

7. *Mulleins and Rocks*, c. 1932–1939 45
 Oil on plywood, 30.3 x 35.6 cm
 National Gallery of Canada
 Gift of the Heward family, Montreal, 1948

8. Study for *Farmhouse Window*, c. 1938 46
 Oil on canvas, 51.4 x 44.5 cm
 Coll: Laura and Byrne Harper

9. *Girl in the Window,* 1941 48
 Oil on canvas, 86.4 x 91.5 cm
 Art Gallery of Windsor
 Given in memory of the artist and her sister by the estate of Gladys S. Nares, 1981
 1981.006

10. *Pensive Girl,* 1944 50
 Oil on canvas, 51 x 43.5 cm
 Musée d'art contemporain de Montréal
 Gift of the Max and Iris Stern Foundation
 Photo: Denis Farley
 D 88 121 P1

11. *At the Café (portrait of Mabel Lockerby),* n.d. 52
 Oil on canvas, 68.5 x 58.4 cm
 Gift of the artist's family
 Coll: The Montreal Museum of Fine Arts
 Photo: Brian Merrett, MMFA
 1950.1036

MABEL LOCKERBY (1882–1976)

1. *March,* n.d. 54
 Oil on canvas, 55.5 x 70.5 cm
 National Gallery of Canada
 Purchased 1926

HENRIETTA MABEL MAY (1877–1971)

KATHLEEN MORRIS (1893–1986)

2. *Waiting*, n.d. 72
 Oil on panel, 26.7 x 34.2 cm
 National Gallery of Canada
 Purchased 1924

3. Kathleen M. Morris, 1930 74
 Photo by Melvin Ormond Hammond, 21.3 x 16.3 cm
 NGC Library
 63006

4. *Waiting at the Old Church, Berthierville, Québec*, c. 1924 75
 Oil on canvas, 50.8 x 61 cm
 Private Collection, Ontario

5. *Market Day, Ottawa*, 1924 76
 Oil on panel, 25.4 x 36.8 cm
 Private Collection, Ontario

6. *Point Levy, Québec*, c. 1925 76
 Oil on canvas, 45.8 x 61.2 cm
 National Gallery of Canada
 Purchased 1926

7. *After High Mass, Berthier-en-Haut*, 1927 77
 Oil on canvas, 61 x 71 cm
 Purchase, gift of William J. Morrice
 Coll: The Montreal Museum of Fine Arts
 Photo: Brian Merrett, MMFA
 1927.479

5. *Martha*, c. 1938 88
 Oil on canvas, 76.7 x 61.4 cm
 Musée national des beaux-arts du Québec
 Photo: Jean-Guy Kérouac
 40.13

6. *Portrait of Frère Adélard*, 1939 89
 Oil on canvas, 91.6 x 76.4 cm
 National Gallery of Canada
 Gift of Alan D. McCall, Montreal, and Dr. G.R. McCall, Montreal, 1982

7. *Still Life of Lilies*, c. 1940 90
 Oil on canvas, 64.0 x 62.0 cm
 Collection of the Agnes Etherington Art Centre, Queen's University, Kingston
 Purchase, Chancellor Richardson Memorial Fund and Wintario matching grant, 1979
 22-040

SARAH ROBERTSON (1891–1948)

1. *Eastern Townships*, n.d. 92
 Oil on panel, 29.2 x 34.4 cm
 Collection of the Agnes Etherington Art Centre, Queen's University, Kingston
 Bequest of Basil Nares in memory of Prudence Heward and her sister Gladys Heward, 1981
 24-023

2. Sarah Robertson sketching outdoors, n.d. 94
 Photo, 16.5 x 16.7 cm
 NGC Library
 63093

ANNE SAVAGE (1896–1971)

1. *Portrait of William Brymner*, 1919 14
 Oil on wood, 22.86 x 17.78 cm
 Art Gallery of Hamilton
 Gift of the artist, 1959

2. *April in the Laurentians*, c. 1922-1924 100
 Oil on canvas, 50.9 x 61.5 cm
 National Gallery of Canada
 Gift of Anne McDougall, Ottawa, 1997

3. Savage, Anne 102
 Photo
 Courtesy of Leah Sherman

4. *La Maison Rouge*, Dorval, c. 1928 103
 Oil on canvas, 51 x 61.7 cm
 Musée national des beaux-arts du Québec
 Photo: Jean-Guy Kérouac
 95.11

5. *The Plough*, 1931-1933 104
 Oil on canvas, 76.4 x 102.3 cm
 Gift of Arthur B. Gill
 Coll: The Montreal Museum of Fine Arts
 Photo: Brian Merrett, MMFA
 1970.1652

ETHEL SEATH (1879–1963)

1. *The Gardener's House*, c. 1930 112
 Oil on canvas, 62.5 x 67 cm
 National Gallery of Canada
 Purchased 1931

2. *Shells*, c. 1937 113
 Oil on canvas, 51.4 x 48.7 cm
 National Gallery of Canada
 Purchased 1997 from the Evelyn de Rostaing McMann Fund

3. *The White Barn, Eastern Townships*, c. 1941 114
 Oil on canvas, 71.5 x 86.5 cm
 National Gallery of Canada
 Purchased 1948

4. *Pears in a Window*, before 1944 116
 Oil on canvas, 63.5 x 61.2 cm
 Purchase, Robert Lindsay Fund
 Coll: The Montreal Museum of Fine Arts
 Photo: Brian Merrett, MMFA
 1944.858

5. *Undergrowth*, 1954 118
 Oil on canvas, 50 x 60 cm
 Collection Lavalin du Musée d'art contemporain de Montréal
 Photo: MACM
 A 92 821 P1

INDEX